IMAGES
of America

SYCAMORE

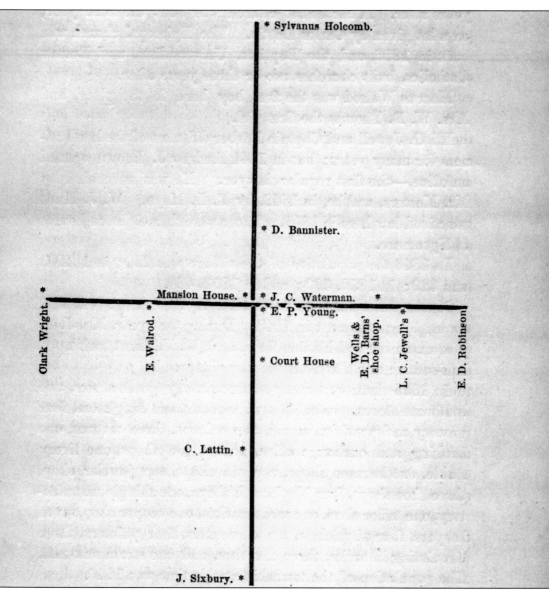

This 1840 map of Sycamore was included in the 1868 *History of DeKalb County, Illinois*, by Henry L. Boies. The map is shown as it was published, with east at the top, and north to the left. Boies added this description: "In 1840 the dreary, little village consisted of a dozen houses, scattered over considerable land, but without fences, and with but one well."

On the cover: Anaconda Wire and Cable Company employees and their families posed for a group photograph during the 1936 company picnic at the Farm, a popular resort 12 miles east of Sycamore on Route 64. (Courtesy of the Joiner History Room.)

IMAGES of America

SYCAMORE

Phyllis Kelley
and the Joiner History Room Staff

Copyright © 2007 by Phyllis Kelley and the Joiner History Room Staff
ISBN 978-0-7385-5139-5

Published by Arcadia Publishing
Charleston, South Carolina

Printed in the United States of America

Library of Congress Catalog Card Number: 2007926505

For all general information contact Arcadia Publishing at:
Telephone 843-853-2070
Fax 843-853-0044
E-mail sales@arcadiapublishing.com
For customer service and orders:
Toll-Free 1-888-313-2665

Visit us on the Internet at www.arcadiapublishing.com

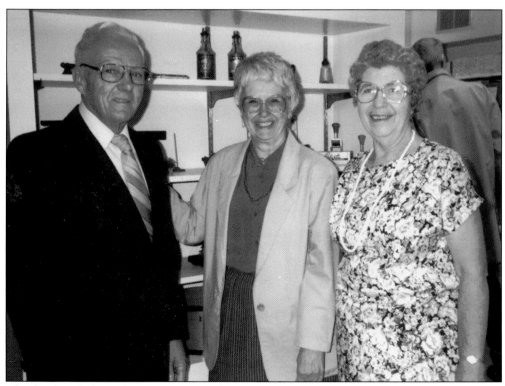

This book is dedicated to Sycamore residents Ralph and Bertha Joiner, who served as DeKalb County clerk and deputy clerk from 1954 to 1974. It is thanks to them that so many early county records now at the Joiner History Room were saved. This photograph of the Joiners with Phyllis Kelley, center, was taken at the 1989 opening of the Joiner History Room.

CONTENTS

Acknowledgments		6
Introduction		7
Foreword		8
1.	State and Main, Where It All Began	9
2.	Around the County Courthouse	33
3.	From Horse and Buggy to Trains, Planes, and Automobiles	45
4.	Sunday Worship and Book Learning	57
5.	Made in Sycamore	75
6.	Leading Ladies and Gents	85
7.	Life Offers More in Sycamore	107
Index		126

Acknowledgments

The list of those who must be recognized for making this book possible begins with the many DeKalb County officials who have placed value on preserving historical information. Former county clerks Ralph Joiner and Terry Desmond deserve particular recognition for their efforts to have the county's oldest records saved and organized. In 1989, the DeKalb County board created the county historian position and established the Joiner History Room (JHR) in its original courthouse basement location. The name honors Earle Joiner and his son Ralph, who were county clerks. Earle served from 1926 to 1954 and Ralph served from 1954 to 1974. In 1998, county officials arranged for the history room's move to larger quarters at Sycamore Public Library. Under the jurisdiction of DeKalb County's government, the JHR is staffed by volunteers. Donations and grants provide much of the funding.

Hundreds of individuals have contributed the photographs, newspapers, books, diaries, and other historical documents that have been added to the original core collection of county records at the JHR. The research for this book has been done using these published and unpublished sources. Unless otherwise credited, the photographs in this book are from the JHR archives. We thank all those who generously loaned photographs.

There have been many who assisted in preparing this book for publication. A special thank-you to volunteer Sue Breese who scanned the photographs, typed, and kept track of our progress with her spreadsheets. Without her enthusiasm and encouragement this book would not have made it to the "finished" line. I also want to thank the following JHR volunteers: Marian Anderson, Sheri Baker, Bud Burgin, Jackie Tyrrell, and Mary Chapman. They all pitched in on finding the right photographs and researching the stories behind the images. Special appreciation goes to our good friend Robert J. (Bob) Myers for his pen and ink sketches. For their many hours of proofreading, fact checking, and editing, special thanks to Patsy Lundberg, Fran Besserman, and Maureen Kelley.

Introduction

This book is a photographic journey through Sycamore's history, from its beginning to recent times. It tells the stories of many of the people, businesses, schools, churches, homes, organizations, and events that have shaped this special community.

The foundations for Sycamore's future were set in the pivotal year of 1839, two years after the formation of DeKalb County. The name of this small settlement on the treeless prairie was changed from Orange to Sycamore. Capt. Eli Barnes and James S. Waterman staked out the original village with the broad streets that are still enjoyed today. Barnes built the large tavern (inn) that provided much-needed lodging. Defeating rivals Coltonville and Brush Point (a Mayfield Township settlement), Sycamore became the county seat and home to the first building constructed as DeKalb County's courthouse.

The early settlers of Sycamore were primarily New Englanders whose ambition and entrepreneurial spirit brought them west seeking land and new opportunities. They built a town literally from the ground up. The courthouse provided a meeting place for churches, schools, and organizations before buildings for those purposes existed. Barnes, Carlos Lattin, Jesse C. Kellogg, and brothers James S. and John C. Waterman were typical of the founding fathers who took on many roles, including owning farms and commercial businesses, holding public offices, and providing leadership in establishing churches and fraternal organizations.

After Sycamore leaders placed their faith and money with a rival railroad that was never built, the Galena and Chicago Union Railroad (later Chicago and North Western Railway) line bypassed the town and laid its tracks through DeKalb and Cortland in 1853. Sycamore's economic future was secured when local investors raised $75,000 to form a corporation—the Sycamore, Cortland, and Chicago Railroad. The company's four miles of track connected Sycamore to Cortland in 1859.

Over 300 men from Sycamore served in the Union army during the Civil War, and the veterans who returned played a prominent role in the town's development for the rest of the 19th century. During that period, many substantial business blocks, churches, and schools were built, and large-scale manufacturing began.

The early 20th century was a time of many improvements: Dr. Letitia Westgate erected the city's first hospital in 1900, the electric streetcar line connected Sycamore and DeKalb in 1902, the signature limestone county courthouse and the Pierce Building (now Sycamore Center) were built in 1904, the domed public library was completed in 1905, the county jail was finished in 1912, the post office was added in 1915, and the high school on East State Street was built in 1916.

The prosperous 1920s saw more progress: the park district was formed in 1923, and Sycamore Community Park opened in 1925, Ideal Commutator Dresser Company (later Ideal Industries) moved its fledgling business to Sycamore in 1924, developer Henry Fargo erected the theater (1925), garage (1926), and hotel (1927) that carried his name, and the old Universalist church was converted to a community center in 1928.

Sycamore has continued to evolve through the decades, meeting the challenges of the Great Depression of the 1930s, the World War II era, the postwar baby boom, and beyond. Images from more recent years appearing on these pages include Mayor Harold "Red" Johnson, the Marlyn Majorettes, a Lyn Bute snow sculpture, the Turner Brass Olympic Torch, Wally "Mr. Pumpkin" Thurow, the Midwest Museum of Natural History, and the Pay-It-Forward House.

Foreword

Ask historians and they will usually say that the study of history is a process more than a science. It is finding, organizing, and interpreting the information of our less than predictable lives. In a sense, one "does" history because the process is an active one that hopefully leads to an ability to see and learn from dissimilar situations. The historian learns vicariously about other lives, and the key to understanding how to move from the past into a creative future is the source material that shaped and resulted from those past lives.

For over 25 years, DeKalb County historian Phyllis Kelley has organized sources of information about the county's past. Much of this information concerns DeKalb County's vibrant county seat: the city of Sycamore. From 1840, when a county seat controversy was settled in Sycamore's favor by the Illinois legislature, until the present day, Sycamore's rich history has been inextricably woven with the county's history. Since 1989, Phyllis and her dedicated staff at the Joiner History Room have gathered and preserved newspaper sources, diaries, letters, memoirs, naturalization records, genealogical manuscripts, cemetery records, photograph collections, maps, and a variety of histories and official records concerning Sycamore and the wider county of DeKalb.

So if you are in picturesque Sycamore to view our historic homes or to patronize our walkable central business district, please investigate the diverse and growing collection of historical sources at the Joiner History Room. It will inspire the historian in you and make you want to "do" history as well.

<div style="text-align: right;">
Bill Nicklas

City Manager, Sycamore
</div>

One

STATE AND MAIN, WHERE IT ALL BEGAN

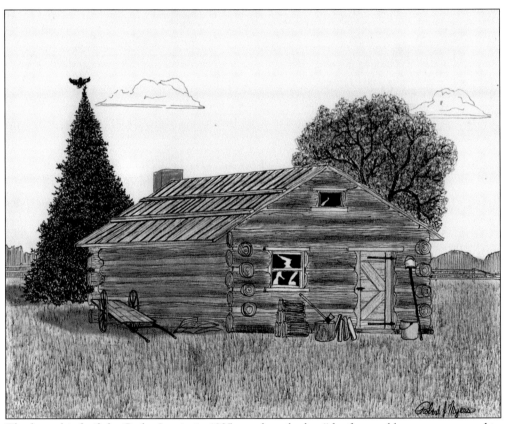

The log cabin built by Carlos Lattin in 1835 was described as "the first real home constructed in Sycamore" by longtime local historian O. T. Willard. The cabin, occupied by Lattin for 10 years, stood 68 feet north of the current 307 West State Street location of Downtown Shoes. Willard wrote: "In the pioneer scale of measurement it was eight logs high, 16 by 24 feet in size. The roof was made of shakes, or narrow slabs, three rows on a side, and held down by poles running lengthwise of the roof. One door and one window were stationed on the south side, above which, was a small window in the upper half story. A mud chimney was built against the north gable." This is an original drawing by Robert J. Myers.

Eli Barnes built the first commercial building in Sycamore in 1839. His venture of building a tavern (inn) coincided with the relocation of county government from Coltonville to Sycamore's new two-story frame courthouse. Barnes' Mansion House faced State Street on the northeast corner of State and Main Streets. It was home to doctors, lawyers, and merchants before their homes were built. This photograph of the City Hotel, as it was later known, was taken in 1904 just before the structure was moved across State Street to make space for the new library. In 1914, the old hotel was jacked up and moved again to allow construction of the post office. The historic building's final location was at the southeast corner of Main and Page Streets, where it became the Sinclair Inn. The 120-year-old structure housed the Hole in the Wall tavern and apartments when it was gutted by fire in February 1959.

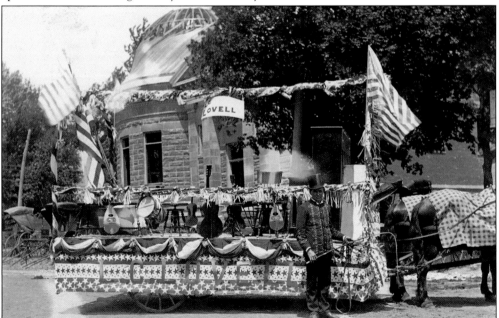

The L. C. Lovell music store sponsored this 1904 Fourth of July parade float. A view of the library dome under construction appears in the background.

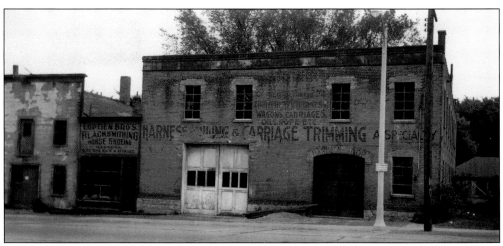

In 1874, Claus Loptein followed his partner, Henry Franzen, in emigrating from Germany to Sycamore, and they opened a blacksmith shop together. Loptein and his sons later expanded the State Street business, manufacturing carriages, wagons, and sleighs in the larger brick building built on the west side of the original. The small blacksmith shop is in the center, and the carriage building is on the right in this photograph. The Loptien name can still be seen today on the top of the larger structure at 126 East State Street, which now houses a laundromat. When the 1874 blacksmith shop was torn down in 1950, it was the last place in town with a smithy to shoe horses. The Loptien Blacksmith sign later found a home at the Harold Warp Pioneer Village Museum in Minden, Nebraska.

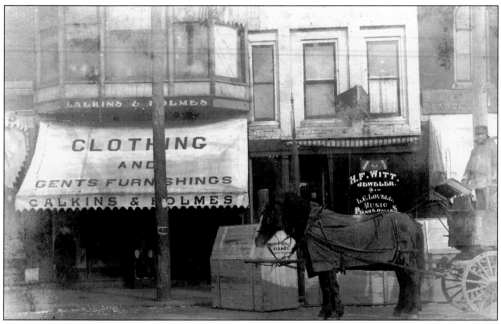

A drayman and his horse pose next to a wood crate delivered to the L. C. Lovell music store (right) on West State Street. Lovell sold pianos and organs in a shop shared with jeweler H. F. Witt. Calkins and Holmes, a men's clothing store, stood next door.

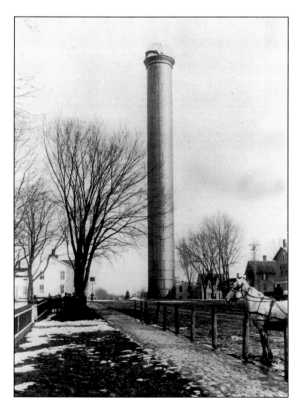

This 135-foot standpipe and a pumping station furnished water for the city of Sycamore from 1888 to 1903. It stood prominently in the wide intersection of State and Main Streets. After the standpipe was removed, a decorative fountain was placed in this location.

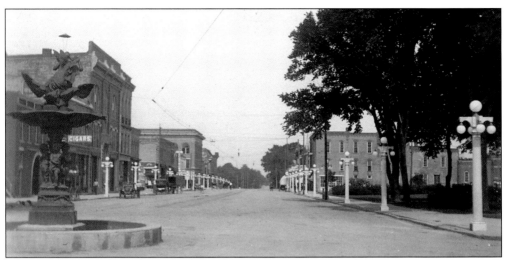

The city's water standpipe was replaced by the ornamental fountain (left) in this photograph that looks west from the intersection of State and Main Streets. A gift of Lucetta Boynton, wife of Charles O. Boynton, the 12-foot-high fountain featuring a mother and child was erected in 1907. In response to a petition alleging it was an obstruction to traffic, the city council voted in 1912 to remove the fountain. There were hints in the local newspaper that many just were not fond of its appearance.

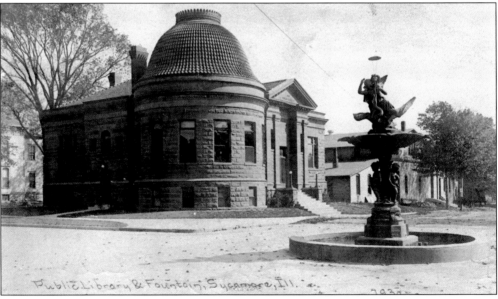

A $12,000 grant from library philanthropist Andrew Carnegie was the primary source of funding for the construction of Sycamore Public Library in 1905. Former mayor Frederick B. Townsend donated the land, the historic site of Eli Barnes's 1839 Mansion House, and the original furnishings. The striking building, featuring Lake Superior red sandstone and a tile-roofed dome, was ideally located on the northeast corner of State and Main Streets, just east of the new courthouse. In 1905, the library included a smoking and reading room for men only in the basement. The exterior of the library's 1996 expansion was carefully blended with the original building. A highlight of the library's 2005 centennial was opening the cornerstone and viewing the historic contents placed there 100 years earlier.

The original portion of this house at 232 South Main Street was built in 1842 by one of Sycamore's pioneer settlers, Jesse C. Kellogg. The 1842 date makes it the oldest known residential structure still standing in Sycamore. Kellogg, an ardent abolitionist, was living here when he was a faithful conductor on the Underground Railroad during the pre–Civil War years. He and his sons were known for helping many escaped slaves make their journey to freedom in Canada. The house was extensively expanded and altered by later owners.

Built in 1872 for William W. Marsh at a cost of about $10,000, this house still stands at 740 West State Street. Marsh, along with his brother Charles W., patented the Marsh Harvester and manufactured it in their Sycamore factory. The wooded area surrounding this mansion, known as Marsh's Park, was the perfect setting for the annual Chautauqua programs of the early 20th century.

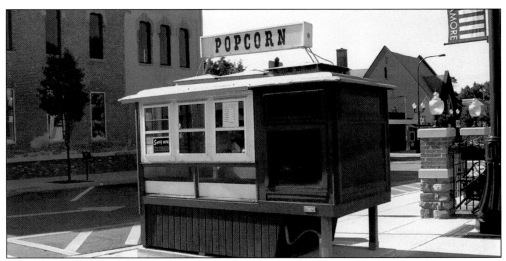

Sycamore's landmark popcorn stand was purchased, probably in the 1890s, by James Elliott from the Kingery Company of Cincinnati, Ohio. The stand was originally a wheeled wagon, stored nightly at a livery stable. In addition to parking daily on the northwest corner of State and Maple Streets, Elliott sold popcorn and candy throughout the town with his horse pulling the rig. After Elliott moved away in 1921, local businessmen purchased and refurbished the wagon for Edward Lobaugh, who had lost his vision. The wheels were removed and the stand was moved to its location at the southwest corner of State and Maple Streets in 1923, with electricity and gas being supplied from beneath the sidewalk. Several ownerships and repairs later, the opening of the popcorn stand each year is still a sign that spring is around the corner.

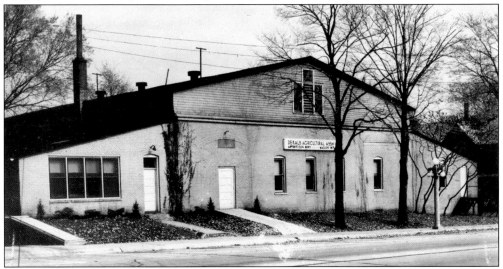

This building stood at 111 East State Street on the property now occupied by Sycamore Public Library's parking lot and 1996 addition. Frederick B. Townsend purchased the property in 1900 and constructed brick livery feed stables operated by Hiram Ostrander. In 1919, the State of Illinois agreed to rent the building for use as an armory. The DeKalb Agricultural Association (later DeKalb AgResearch) purchased the property when the new National Guard armory was built. When this photograph was taken, the company's advertising offices were here; the DeKalb Chix hatchery was moved in later. After DeKalb AgResearch donated the property to the adjacent library, the building was razed in 1975.

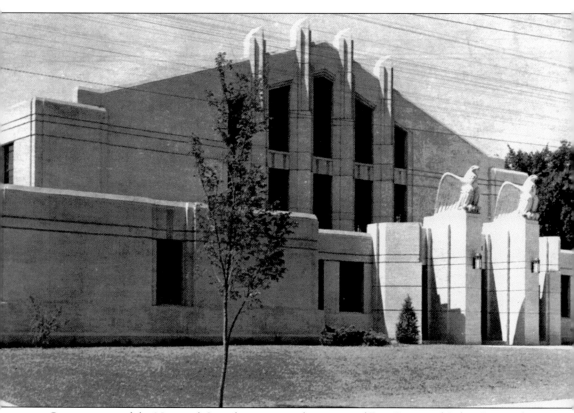

Construction of the National Guard armory on the corner of East State and Sabin Streets from 1936 to 1939 was a Depression-era Works Progress Administration (WPA) employment project. Twelve other Illinois armories of the same basic design were completed by the WPA in 1939. Local citizens raised $1,000 to purchase the lot. A newspaper noted that the 90-by-144-foot drill room would be "the largest room without center supports in Sycamore." A rifle range was built into the basement. An estimated 4,000 people attended the dedication of the new home of the 129th Infantry Regiment of the Illinois National Guard on September 18, 1939.

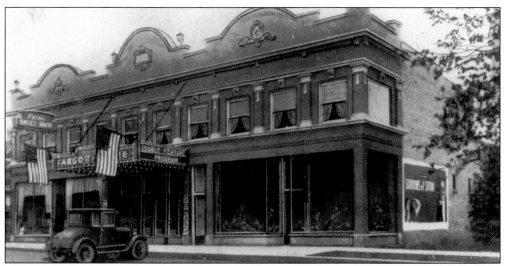

Henry Fargo, a wealthy real estate developer from Geneva, built the 850-seat Fargo Theatre at 420 West State Street in 1925. Movies with sound were first shown in 1928, and air conditioning was added in 1939. Silent films, talkies, vaudeville, minstrels, and other stage shows were all part of the Fargo's history. After Henry Fargo sold the business in 1940, the name was changed to State Theatre. Kids can still eat popcorn and see Saturday matinees at the locally-owned Sycamore State Theatre, which now features three screens.

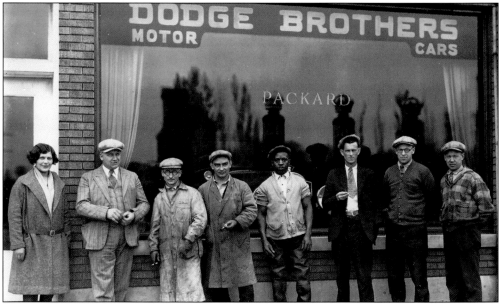

In 1926, Fargo also built the Fargo Garage, an automobile repair shop and salesroom at 437 West State Street. Fred Raymond, a Sycamore playwright and actor, was the first owner. For the grand opening of the garage, Raymond attracted a huge crowd by staging a performance of his play *Missouri Girl*. Raymond soon went back to promoting theatricals, and sold the garage to brothers Einer and Vincent Hillquist in 1928. While the window in this undated photograph advertises Dodges and Packards, the Hillquist family's Fargo Motors became a longtime Buick dealership. The Fargo staff is shown, from left to right, including Emy Hillquist, Fred Floto, Sam Lawler, Clayton Listy, Felix Moore, Mike McMenamin, Einer Hillquist, Vincent Hillquist.

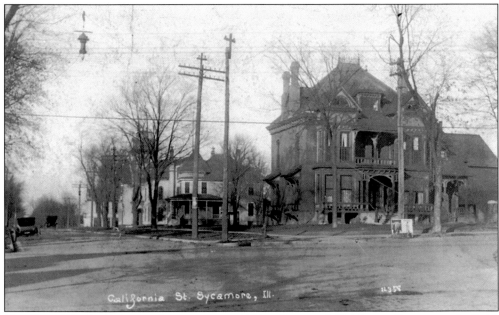

The Fargo Hotel on the northeast corner of West State and California Streets was built by Henry Fargo of Geneva. When Fargo purchased the site, Mary Whittemore was living there in the mansion once owned by former mayor and U.S. congressman Reuben Ellwood (above). Fargo agreed to the restriction that part of the structure be saved and incorporated into the new building as Whittemore's own private suite. When the hotel opened in 1927, the room rate was $1.50 per night, or $2.50 for the few rooms with a private bath. The Stratford Inn, as the hotel was renamed when it reopened after a complete renovation in 1983, continues to offer lodging in master suites that were part of the 19th-century Ellwood home. (Above, courtesy of Bob and Sue Rozycki.)

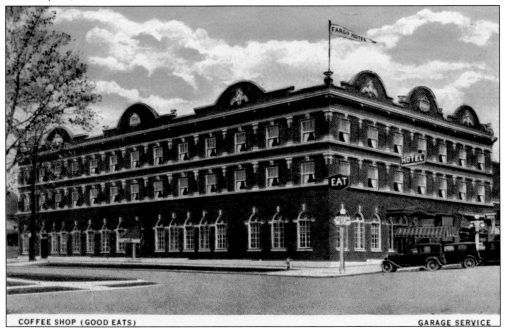

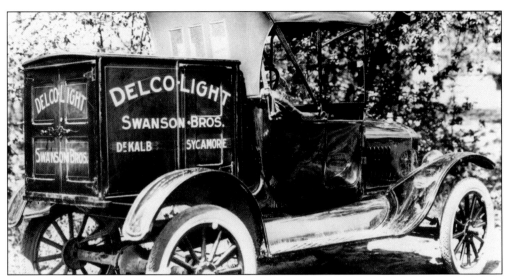

This early Swanson Brothers truck advertises the Delco Light power generator systems that were sold to many farmers before rural electrification. Ed Swanson operated the Sycamore branch of this electrical appliance business from 1911 to 1948 and served on the local school board for many years. Swanson installed a "radio outfit" that enabled the teachers and students at Sycamore High School to hear the live broadcast of Pres. Herbert Hoover's inauguration on March 4, 1929. The *True Republican* noted that, "one can but stop and marvel at the miracles of this age when every boy and girl in a school in a small Illinois city many hundreds of miles away from Washington can hear the president's voice."

This Colonial-style brick building at 127 South Main Street was opened as a hotel and boardinghouse by Mads Peter Johnsen, a native of Denmark, in 1876. Johnsen also offered feed stables that were open to the general public. He and his wife, Mary, operated their hostelry together until his death in 1891, and she continued to house boarders there for some time before her death in 1906. The Johnsen House was a popular lodging place for men who came from the rest of the county for circuit court sessions.

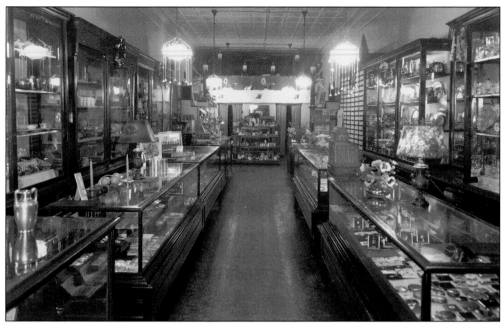

Brothers Ira, Earl, and Vernon Wetzel opened their first downtown jewelry store in 1911. The *True Republican* reported in 1941 that after 30 years in business, the Wetzels had sold over 1,500 watches and completed 13,400 watch repair jobs. The store was closed at its final location, 245 West State Street, after over 40 years of sales and service. This undated photograph shows the elegant interior of Wetzel Brothers.

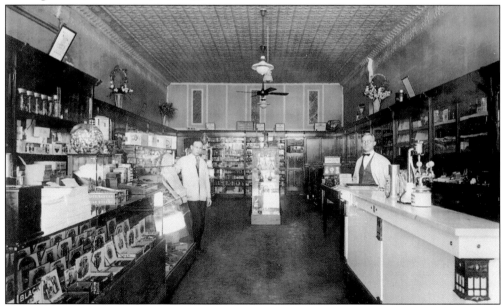

In 1923, the Barker and Sullivan drugstore of Rochelle opened a Sycamore branch at 245 West State Street. Barker and Sullivan remodeled the store, adding "an up-to-date soda fountain" to their complete line of drugs. The pharmacy's soda fountain can be seen in the foreground of this photograph. Barker and Sullivan closed the Sycamore store in 1932. Paulsen Appliance and Electronics occupied the old drugstore in 2007.

In 1934, Louis and Rosalie Ferguson opened a small pharmacy and sundries shop in their home at 129 South Main Street. Their slogan was "Small in size and large in service," and 24-hour pharmacy service was available to customers who could push an electric button "at any time of night." Senior citizens of today remember it as the corner store where penny candy was sold. Louis is also remembered for his clever poetry. It was the end of an era when this popular gentleman passed away and the store was closed in 1953.

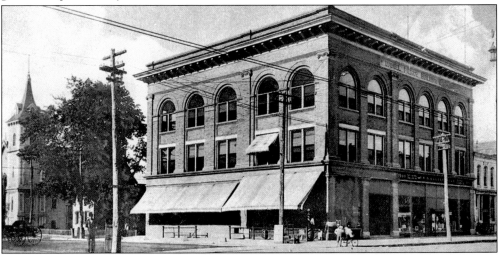

The three-story Daniel Pierce Building at the southwest corner of State and Somonauk Streets was erected in 1904. The first floor was occupied by the Pierce Bank (predecessor of National Bank and Trust) on the east end and the relocated W. M. McAllister dry goods store on the west end. Brothers Noble and Gernon Henderson purchased the dry goods business from William McAllister in 1946. In 1955, they renamed it Henderson's Department Store when the bank moved to its present building. The store's retail space was later expanded onto all three floors and the basement. Noble's son Jerry succeeded him as company president, and this store was family-owned and operated until its closing in 2000. Now owned by the City of Sycamore and renamed Sycamore Center, the building houses city offices.

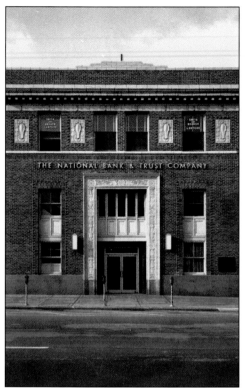

The National Bank and Trust Company of Sycamore, founded by Daniel Pierce in 1867, has occupied this building at 230 West State Street since 1955. At that time, National Bank and Trust moved across the street from the Henderson's building, which was built by Pierce. Along with extensive remodeling in 1955, the DeKalb County area's first drive-up banking window was erected off Somonauk Street. Earlier occupants of this building included the First National Bank, which failed during the Depression, and Strain's grocery.

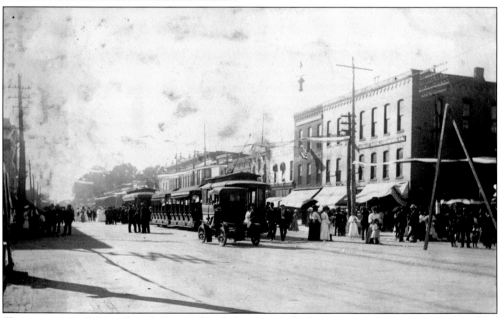

Shop owner L. C. Lovell took this undated photograph looking west on West State Street. The building on the far right, built by Daniel James, was called James' Block until the name was changed to George's Block by a later owner. Several of the facades on the north side of State Street can still be recognized today. The electric trolley line and an early automobile are sharing the use of the wide, brick-lined street.

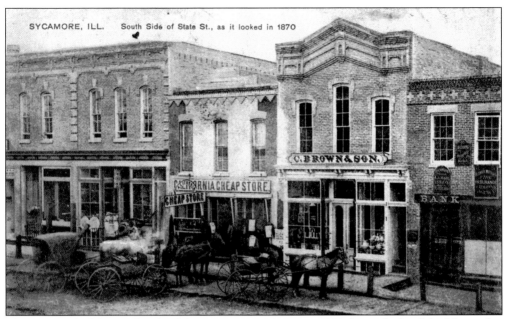

This postcard of the south side of downtown State Street in 1870 shows the brick buildings, dirt street, and wooden sidewalks of that time.

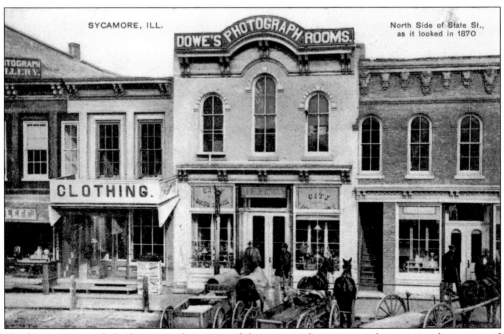

Hitching posts and the horses and wagons of downtown shoppers can be seen in this postcard view of the north side of State Street in 1870.

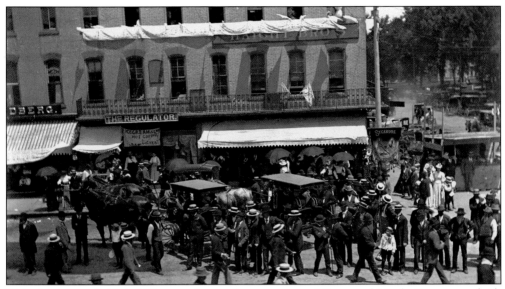

This three-story brick building on the northwest corner of State and Maple Streets was built by Daniel B. James in 1858. The building's name was changed from James' Block to George's Block after James sold the property to his brother-in-law Thomas George and Francis Wilkins in 1861. D. B. James left Sycamore for Springfield, becoming a colonel and aide-de-camp to the adjutant general on Gov. Richard Oglesby's staff during the Civil War. Coast to Coast was one of several hardware stores that were located in this building over many decades. (Courtesy of Nancy Beasley.)

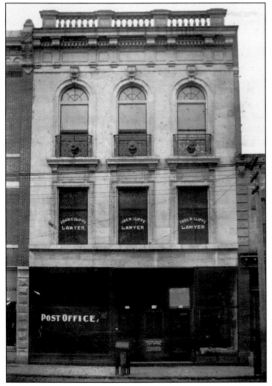

In 1902, the postal service raised Sycamore's classification status, due to increased volume and revenue. With new quarters now required, Frederick B. Townsend contracted with the postal service to rent a portion of the ground floor of the three-story building he planned to construct across from the courthouse. The *True Republican* noted that this building at 156 West State Street would provide "plenty of modern boxes, good light, more help and decent service generally." At this time, all residents had to go to the post office to pick up their mail. In 1906, street numbers were assigned and door-to-door delivery (three times a day) began.

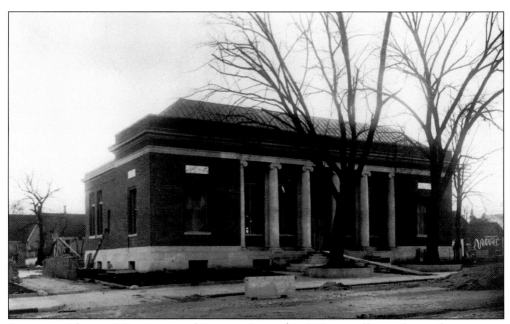

Postmaster Thomas J. Ronin opened Sycamore's new $60,000 post office at the southeast corner of State and Main Streets in April 1915. This photograph was taken during construction. In 1965, the post office was modernized when a sizable addition to the back of the original structure was completed. At a dedication ceremony held on the loading dock in 1965, Sycamore residents were urged help speed the mail by using zip codes, which had been established July 1, 1963.

The three-story Alida Young Temple at 150 West State Street was erected in 1889. Sycamore's Masonic orders occupied the top floor, and the Independent Order of Odd Fellows (IOOF) were on the second. Each group laid its own cornerstone, the IOOF on the northwest, and the Masons on the northeast. Alida Ellwood Young, youngest sibling of the well-known Ellwood brothers of Sycamore and DeKalb, donated $1,000 on condition that the building bear her name. The structure burned in 1963 and was not rebuilt; only the cornerstones remain.

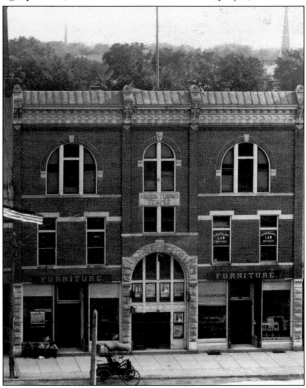

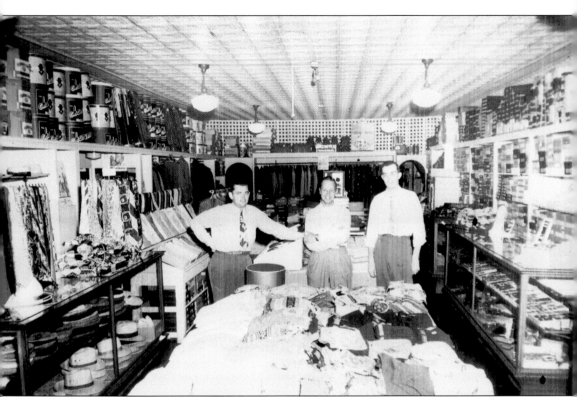

Richard (Ric) Lahti owned and operated a men's clothing store at 223 West State Street from 1941 to 1967. This 1947 photograph of the store's interior is a reminder of the days of full-service retailing. Ready to serve are, from left to right, Robert Kellman, Lahti, and unidentified. Lahti was also the golf pro at Kishwaukee Country Club for several years and was employed at the National Bank and Trust of Sycamore after he left the clothing business.

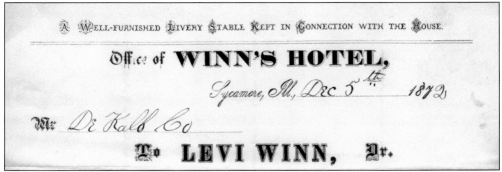

This letterhead of hotel proprietor Levi Winn's 1872 billing to the county noted that livery stable services were provided. That was the 19th century equivalent of having a parking garage. On April 24, 1875, the cornerstone was laid for a new Winn's Hotel at the southeast corner of State and California Streets. The Paine Hotel had previously stood here.

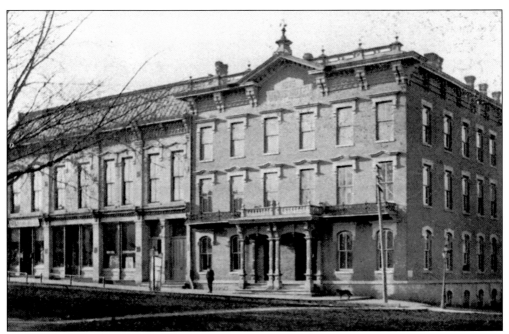

Henry Ward purchased the three-story hotel at State and California Streets (right) from Levi Winn in 1879. Ward hired Chicago architect George Garnsey to design the two-story structure (left), which was added to the east side of the hotel in 1885. Ward's Opera House, an auditorium with full stage and seating for 500, was on the second floor, with retail stores below. The 1941 fire that destroyed the opera house building caused so much damage to the old hotel that the top two floors were later removed. The ground floor of the once-grand old hotel still stands.

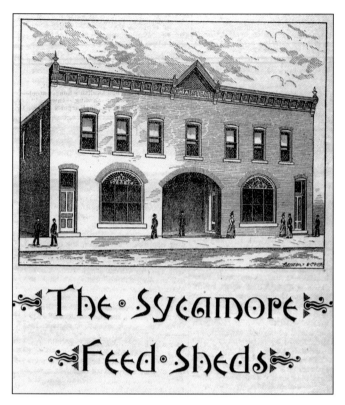

This Sycamore Feed Sheds livery building on Maple Street faced the courthouse. It was built in 1894 by David W. Westgate, who designed it with his daughter, Dr. Letitia Westgate. A December 12, 1894, advertisement in the *True Republican* stated, "The rooms on the right of the driveway consist of the office, the baggage room, and the ladies' waiting and toilet rooms. The barn is commodious, and those wishing to put in their teams without unhitching can do so. Everything under cover, and building furnished with city water and electric lights. Ladies driving to Sycamore are especially invited to call. It costs but ten cents to avail yourselves of all these privileges."

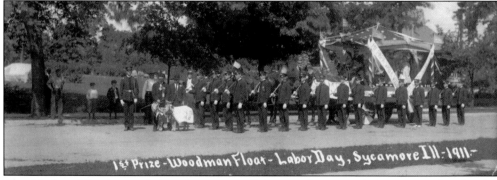

The Modern Woodmen of America were well known for entertaining at parades. In this photograph taken on North Main Street, the uniformed woodmen are carrying axes as they accompany their first-prize float in Sycamore's 1911 Labor Day parade. (Courtesy of Bob and Sue Rozycki.)

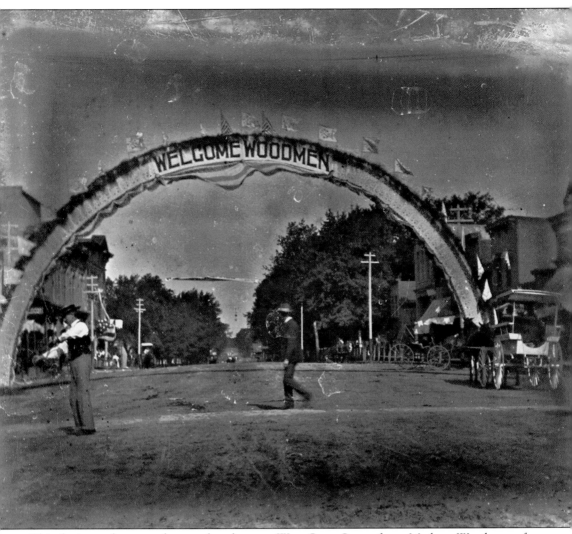

This festive welcome arch was placed across West State Street for a Modern Woodmen of America picnic in 1894. The Modern Woodmen were a popular fraternal benefit and social organization founded in Iowa in 1883.

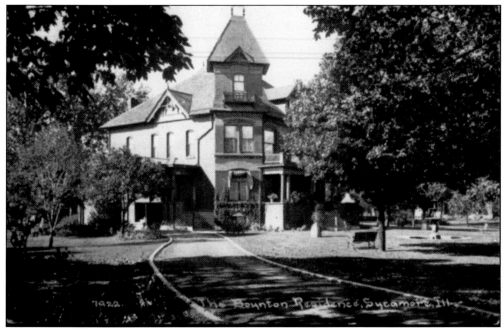

Charles O. and Lucetta Boynton's 1887 red pressed-brick house at 307 North Main Street was designed by George Garnsey, who was the architect of many Sycamore structures and also DeKalb's Isaac L. Ellwood mansion. Among its many elegant features was a third-floor ballroom. Boynton made much of his fortune in land speculation. Three generations of Boyntons lived in the house. Grandson Elmer Boynton Jr. and his wife, Lillian, moved their living quarters to the second floor in 1949 and converted the main floor into a women's apparel and gift shop. Lillian, a beautician, also had a beauty shop in the basement.

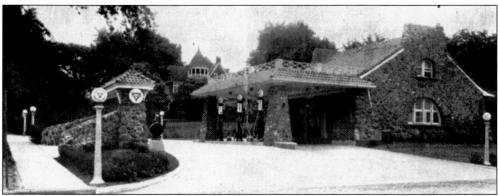

Later advertised as "the most beautiful gasoline filling station in this section of the state," this handsome stone building at 351 North Main Street had been built in 1905 by the neighboring brothers-in-law Elmer Boynton Sr. and Fred Townsend as a garage for their automobiles. Boynton was said to be the first person in Sycamore to own a gasoline motorcar, and the *True Republican* reported in May 1904 that both Boynton and Townsend had ordered four-person Cadillac automobiles costing about $900. When Boynton's "machine" arrived, the newspaper noted that it was painted red. After longtime service as a gas station, the building was transformed into its current use as a restaurant.

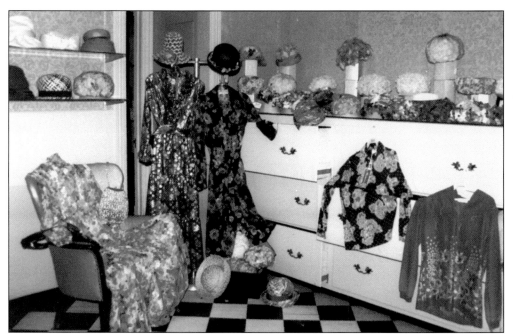

Ladies from Sycamore and neighboring towns did not have to go to Marshall Field's in Chicago for a special outfit. They went to Lillian Boynton's shop to find the perfect dress, hat, gloves, and purse. This 1986 photograph shows one of the salesrooms containing a collection of stylish hats that remained after the shop was closed.

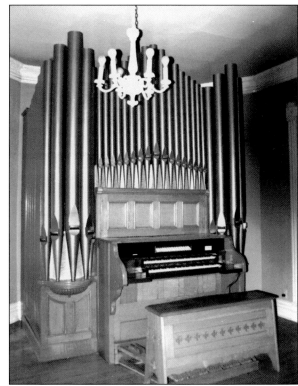

In 1912, Rose and Elmer Boynton Sr. installed this handsome Estey pipe organ in their home at 307 North Main Street. The organ was shipped from Vermont in 17 crates that filled an entire train car.

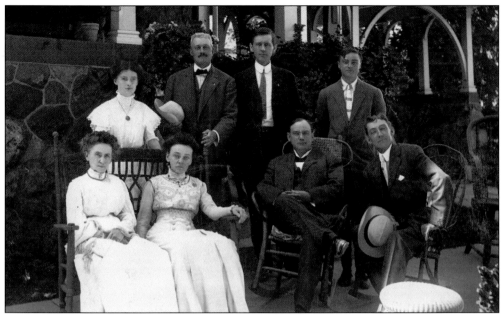

This 1909 photograph shows the Townsend family and guests in front of their North Main Street home. From left to right are (first row) Lucetta Boynton, Mary Boynton Townsend, Joseph W. Folk, and Harry Holbrook; (second row) Eleanor Townsend, Frederick B. (Fred) Townsend, unidentified, and Charles B. Townsend. Folk, a former governor of Missouri, was a speaker at the 1909 Chautauqua; Holbrook was manager of the Sycamore Chautauqua.

The Frederick B. and Mary Boynton Townsend house is an elegant mansion at 331 North Main Street. It was completed in 1893 on the property just north of the home of Mary's parents, Charles O. and Lucetta Boynton. The reported cost was $15,000. A special feature of the house was the use of stone on the front. This fine example of Sycamore's beautiful homes is now open on weekends as a bed and breakfast called the Paper Doll House. Rumor has it that Fred's ghost still roams the premises.

Two

Around the County Courthouse

In the county's early years, the courthouses offered the largest gathering rooms. They were used like community centers for a variety of nongovernment functions, including church meetings, school classes, club meetings, and balls such as the one advertised here in 1852. Such a ball was also held to celebrate the completion of the new brick courthouse in Sycamore in 1851. The population of the village at the time was 435. People came from as far away as Chicago to attend the festive event.

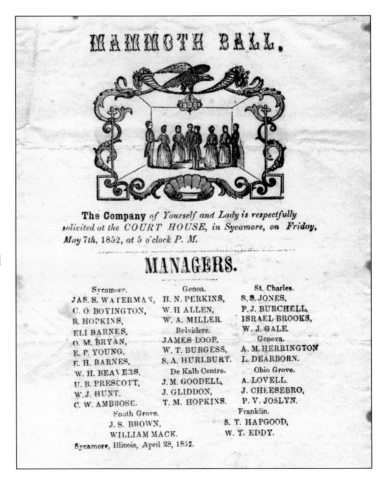

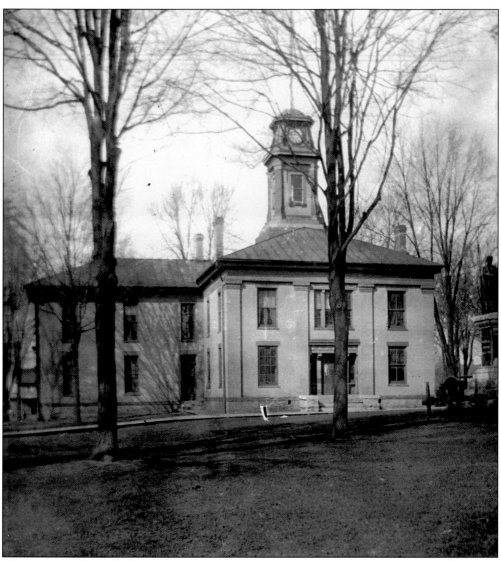

After 10 years, DeKalb County had outgrown its 20-by-30-foot wood frame courthouse on the south side of State Street. The second Sycamore courthouse was built across the street (north side of State Street) from the first. It was constructed of locally-made bricks, obtained from kilns just a few miles from town, and completed in 1851 at a cost of $6,000. This photograph was taken after a two-story addition was built to the west (left) side of the building in 1864. This structure lasted just over 50 years and was dismantled and demolished in 1903 to make way for the present-day third courthouse.

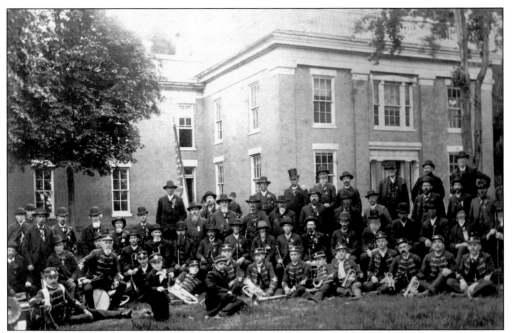

Sycamore's uniformed city band members (front) posed with Grand Army of the Republic (GAR) Civil War veterans in this photograph taken in front of the second courthouse on Decoration Day (now called Memorial Day) in 1884. DeKalb County's GAR Potter Post No. 12 was organized in August 1874.

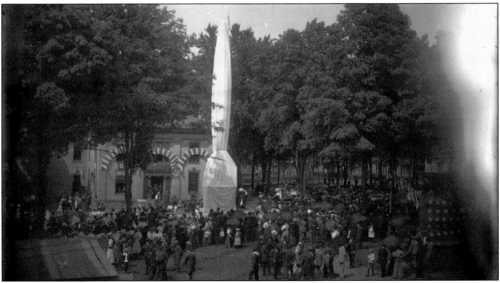

On June 24, 1897, the soldiers monument honoring those from DeKalb County who served in the Civil War was covered before its dedication. The old brick second courthouse was decorated for the occasion as the crowd gathered. Daniel Dustin Craft, grandson of Sycamore's Gen. Daniel Dustin, had the honor of unveiling the monument. After a parade featuring many bands and Civil War veterans from area GAR posts, the crowd filled the courthouse lawn and turned its attention to the speakers' platform. Col. Isaac L. Ellwood, DeKalb's barbed wire baron, gave an address formally accepting the monument on behalf of the people of DeKalb County.

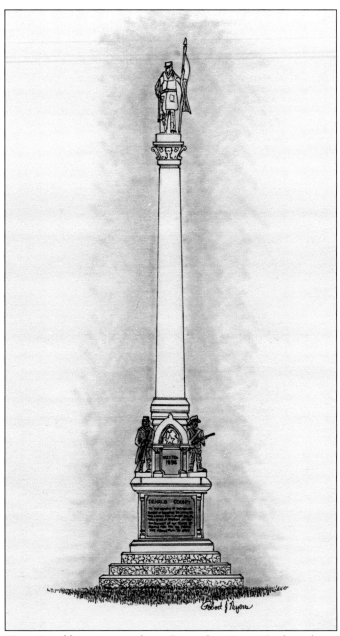

The Sycamore *True Republican* reported on December 7, 1895, that the county board of supervisors selected the design for the DeKalb County soldiers monument presented by J. H. Anderson Granite Company of Chicago. "The design is a very handsome one and will stand just a little over fifty feet high. On the top of the shaft is the granite figure of a color bearer, heroic size, while surmounting the base on each side of the shaft stand two figures in copper-bronze–one of an infantryman at parade rest; the other a dismounted cavalryman ready for action. These figures are from the casts made by Lorado Taft, the celebrated sculptor, possess high artistic merit, and have never been placed on a monument. The two figures alone cost $1,500. The cost of the monument comes just within the $5,000 appropriation, the price being $4,850." This is an original drawing by Robert J. Myers.

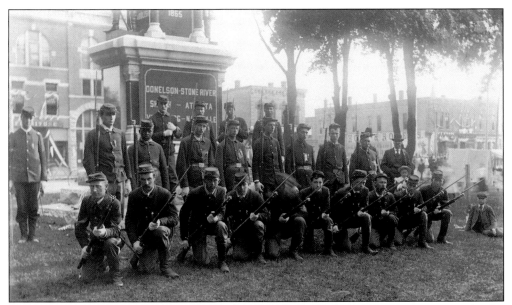

Wearing their fathers' Civil War uniforms, these sons posed by the soldiers monument on the day it was dedicated in 1897. The man second from left in the second row is one of the sons of Henry Beard, the ex-slave who joined DeKalb County troops as a cook during the war. On April 25, 1911, the General E. F. Dutton Camp No. 49, Sons of Veterans was formally organized with 22 charter members. As the ranks of the GAR organization of Union army veterans diminished, Sons of Veterans units were formed to uphold their fathers' patriotic traditions.

These Civil War veterans gathered in front of the courthouse for their annual GAR reunion in 1911.

As plans to build a new courthouse were progressing, leaders of DeKalb put forth a campaign to have the county seat moved from Sycamore to DeKalb. This "petition praying for an election for the removal of the county seat of DeKalb County from the City of Sycamore to the City of DeKalb" was filed July 21, 1902. Its 220 pages included 4,430 names, some listed twice. When county clerk Albert S. Kinsloe did not place the referendum on the November ballot due to a legal technicality, and DeKalb's 1903 case before the Illinois Supreme Court was unsuccessful, Sycamore was victorious.

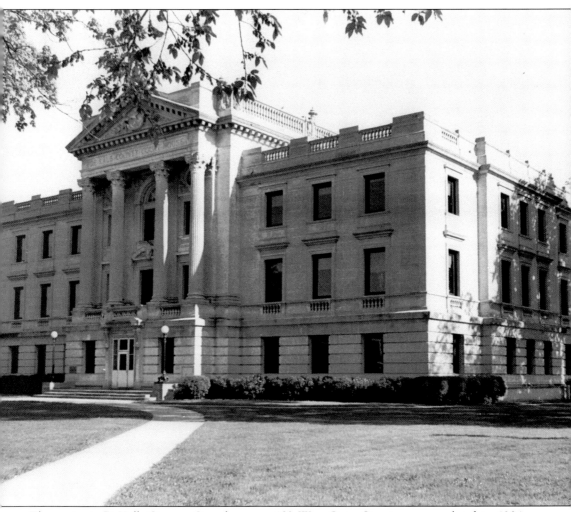

The majestic DeKalb County Courthouse at 133 West State Street was completed in 1904. State architect H. T. Hazleton certified that the payment due to contractor William J. McAlpine totaled $143,897.55. The exterior Bedford limestone was quarried in Indiana then shipped by train and delivered to the construction site using a temporary rail spur. The huge blocks of stone that formed the courthouse walls, some weighing more than four tons, were then cut on site. A major restoration and remodeling of the courthouse took place after the nonjudicial offices moved across Main Street to the county's administration building in 1984.

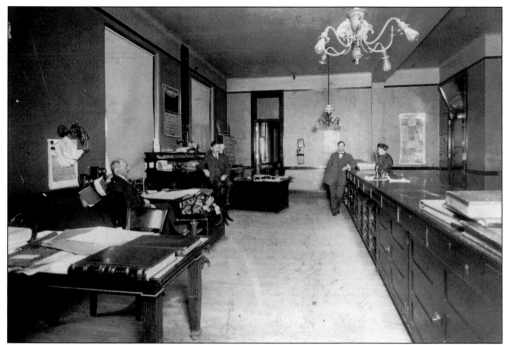

DeKalb County clerk S. M. Henderson is seated in the foreground of this 1911 photograph. Other staff in the county clerk's office at the courthouse are, from left to right, Wallace Whitmore, future county clerk Earle W. Joiner, and Mae Russell.

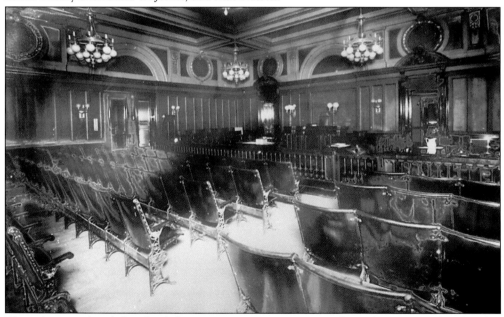

This photograph of the third floor circuit courtroom was taken about 1905, shortly after completion of the current courthouse. The courtroom's 1987 restoration, complete with old chandelier, gilt trim, and original furniture, brought back the elegance of an earlier time. Trial scenes for the movie *Will*, about Watergate conspirator G. Gordon Liddy, were filmed in this courtroom in 1981.

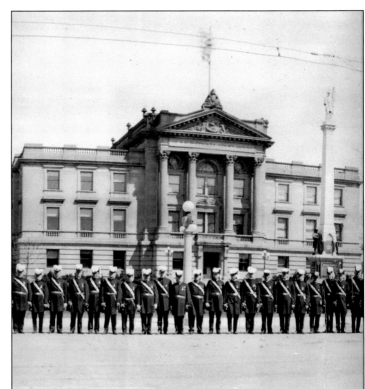

Members of the Sycamore Commandery No. 15 Knights Templar (a Masonic order) line up on the grounds of the courthouse on Easter Sunday morning in 1917. They are preparing to attend services at the Congregational Church.

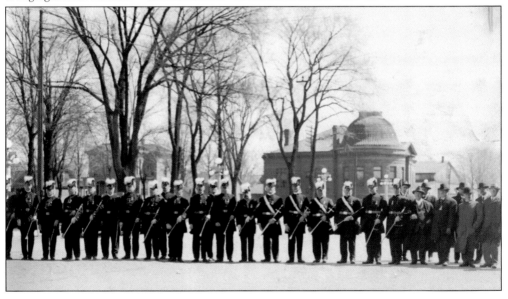

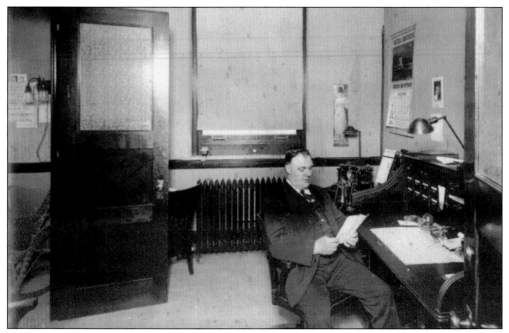

In this photograph taken at his county jail office, sheriff James Scott is working at his roll top desk. Running on the Progressive "Bull Moose" ticket in the election of 1914, he defeated his Republican opponent. He was the only Progressive elected to county office in DeKalb County and served one term.

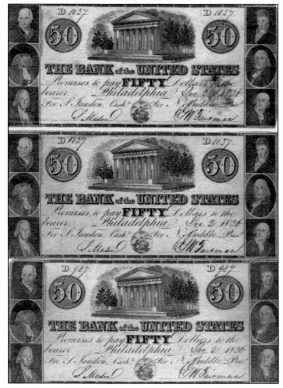

William Taylor, a member of a gang of counterfeiters, was caught and charged with passing bogus bills in DeKalb County in 1838. It was the county's first criminal case. Taylor escaped custody, but these fake banknotes were left as evidence in the courthouse files.

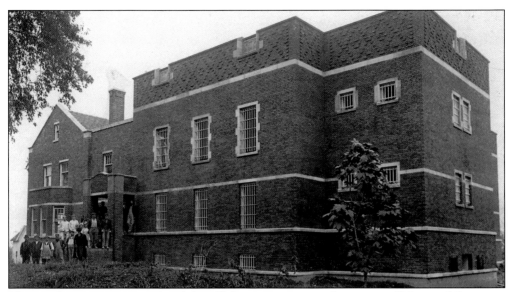

This combination county jail and sheriff's living quarters on the corner of Main and Sycamore Streets was completed in 1912. In 1919, an inspector from Springfield described it as "one of the best in the state." It had juvenile and women's departments, a hospital room, baths and showers, and a padded cell. A toilet, washstand, and two cots were included in each cell. The jail was used at times as a secure lockup for Chicago gangsters, including Jake "the Barber" Factor. The building was remodeled to house county administrative offices after a new public safety building replaced it in 1980.

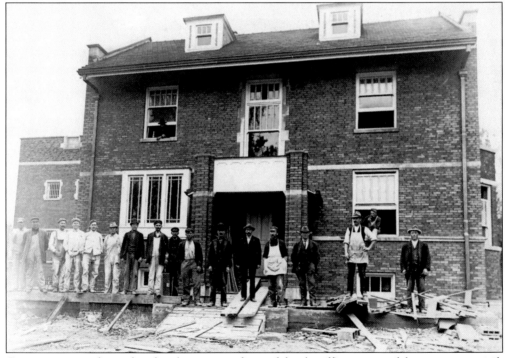

Construction workers take a break to pose in front of the sheriff's quarters of the new county jail. Skoglund and Wedberg was the building's contractor.

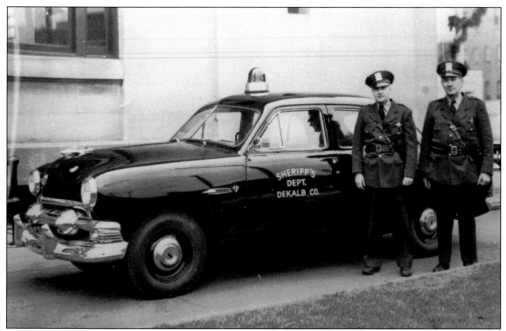

This 1951 Ford squad car was purchased for the DeKalb County Sheriff's Department for about $1,800. Shown standing by their shiny new automobile are sheriff Field Utter (left) and his deputy Virgil Morgan. Utter recalled that the car was traded in for a new one after a couple of years because it had so many miles on it.

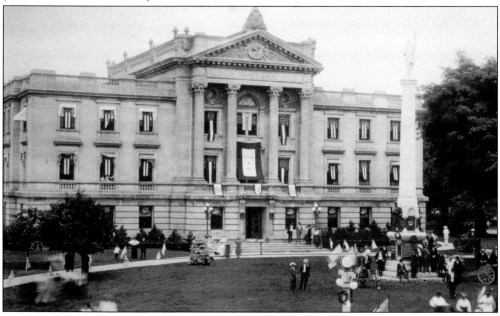

This crowd is lined up in front of the courthouse in June 1919 to celebrate the return of the county's World War I veterans. Patriotic banners draped the courthouse windows. A parade, speeches, a banquet served by the Red Cross, a street dance, and free movies were all part of the celebration. The Sycamore and DeKalb city bands led the parade and gave concerts. Nine Sycamore boys lost their lives in World War I.

Three

FROM HORSE AND BUGGY TO TRAINS, PLANES, AND AUTOMOBILES

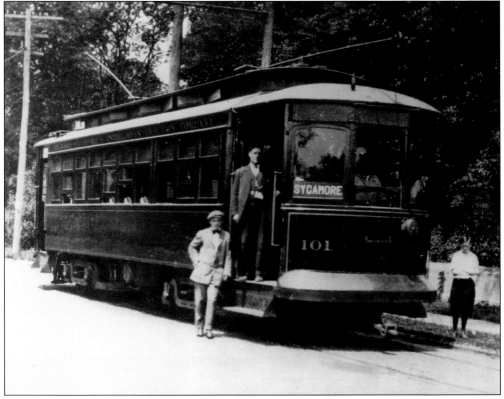

The DeKalb-Sycamore Interurban Traction Company provided passenger service between the two towns from 1902 to 1924. The original fare was 10¢ each way. The electric streetcars ran from 6:00 a.m. until midnight, with departures from Sycamore's courthouse on the half hour. The end of the line in DeKalb was at the west door of the Castle, now Northern Illinois University's Altgeld Hall. Electric Park opened in 1903 near the corner of Coltonville Road and DeKalb Avenue (Route 23), encouraging ridership by offering many popular amusements.

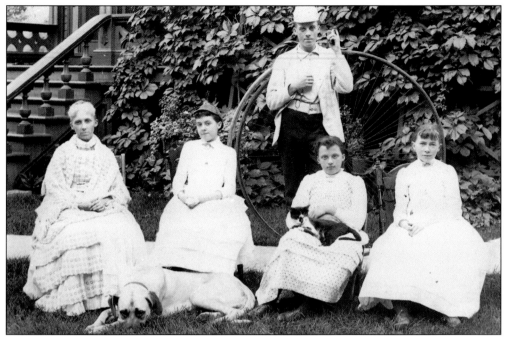

Standing proudly with his high-wheeler bicycle is Daniel Pierce Wild, grandson of banker Daniel Pierce and son of George P. Wild. Seated in front of him, from left to right, are his mother Sarah Wild, sister Elinor, cousin Mary Townsend, and sister Elizabeth. These bicycles were very popular with young men in the 1880s.

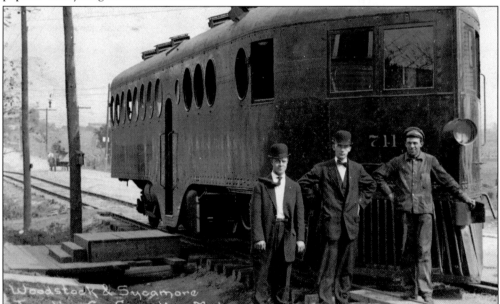

These gents pose in front of a Woodstock and Sycamore Traction Company car. Lasting less than 10 years, this has been described as one of the least successful interurbans ever built. The underfunded company never reached Woodstock; its 27 miles of track running north from Sycamore ended at Marengo. Unable to afford electrifying the track as planned, the owners used gasoline-powered cars until going out of business in 1918.

These photographs show people in different eras taking drives just past the Carlos Lattin house at 305 Somonauk Street. The hitching post for horses can be seen at the curb behind the early automobile.

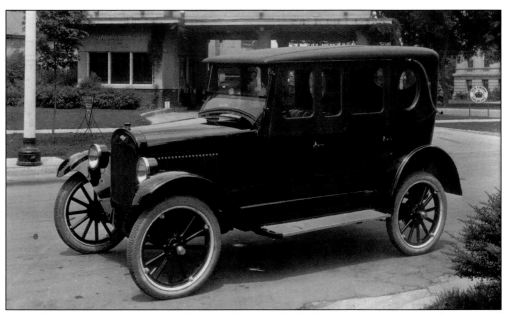

This Chevrolet touring car was parked near the Standard Oil station that stood on the corner of State and Main Streets. A bit of the courthouse can be seen on the far right, along with a sign promoting Standard Oil's Red Crown gasoline brand.

The Galena and Chicago Union Railroad (later Chicago and North Western Railway) bypassed Sycamore in 1853, locating its stations in DeKalb and Cortland. Concerned community leaders banded together to raise $75,000 to build a four-mile connecting branch line to Cortland. The Sycamore, Cortland, and Chicago Railroad, completed in 1859, was sold to Chicago and North Western in 1883, the year after this freight bill was issued. In 1936, the four miles of rail that were once so critical to Sycamore's economy were removed.

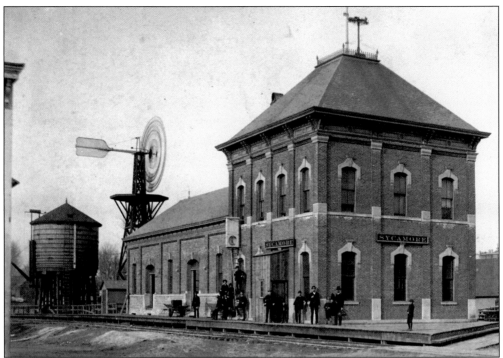

The Chicago and North Western train station on the northeast corner of Sacramento Street and DeKalb Avenue was erected in 1880, while still under the ownership of the local Sycamore, Cortland, and Chicago line. The bricks for the building were made at the kilns north of Sycamore on Brickville Road. The station's unusual weather vane, a six-foot locomotive, can be seen in the view above. The end of passenger service was announced by Chicago and North Western in 1930. In recent years, the old depot has been used as a storage place for Auto Meter products.

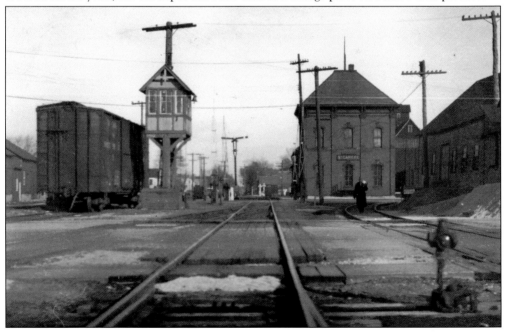

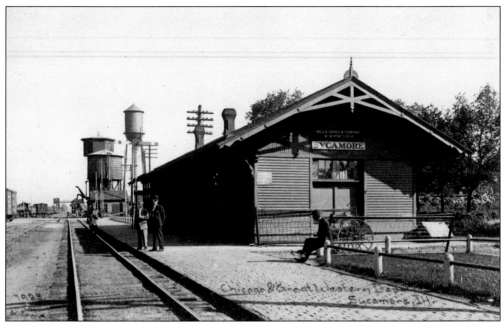

The last section of track connecting Sycamore to Chicago on what was then the Minnesota and Northwestern Railroad was laid on January 28, 1887. This depot for the east–west Chicago Great Western (CGW) Railway, as it was known after 1892, was located on the west side of North Main Street (Route 23) north of Sycamore Street. When the depot was built, it had separate waiting rooms for men and women. The last passenger train from Sycamore left this depot at 2:35 p.m. on August 12, 1956. Bicyclists can now go from Sycamore to St. Charles on a section of the old CGW rail bed called the Great Western Trail.

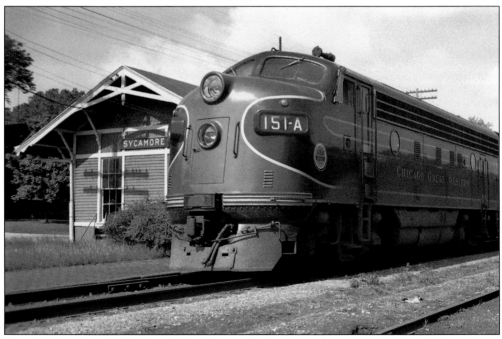

This photograph of CGW diesel No. 151-A at the Sycamore depot was taken in 1951.

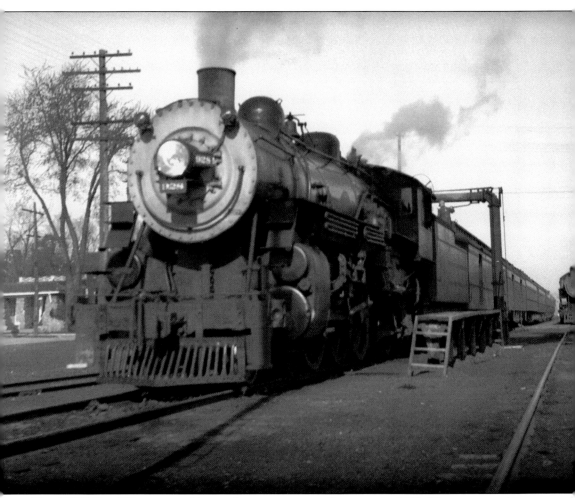

The CGW No. 928 is pictured here taking on water in Sycamore in 1935. The stone gasoline station at 351 North Main Street can be seen in the background (left). This is now the location of the Towne Square restaurant.

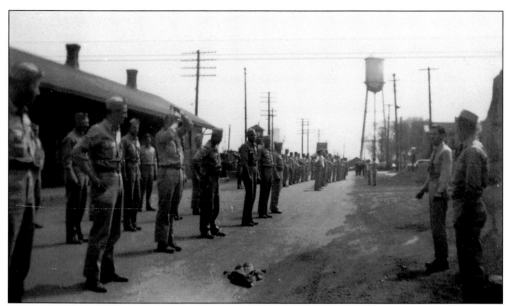
These World War II troops are waiting to board the train at Sycamore's CGW depot in 1943.

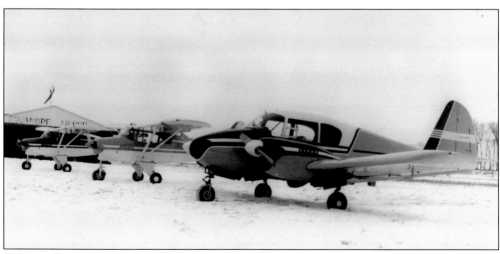
In 1946, the Leader Oil Company of Sycamore purchased 126 acres of farmland just east of the city park on Route 64 for development of a service station and airfield. The Sycamore Airport, always privately owned and operated, had three hangars and was home to about 100 small private planes when the property was sold to the Sycamore Park District at public auction in 1970. The addition of this adjacent property greatly expanded the size of Sycamore Community Park. (Courtesy of Tom Cleveland.)

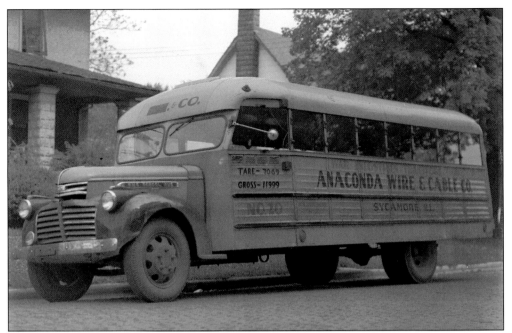

The World War II years were a time of gas rationing and labor shortage. Sycamore's Anaconda Wire and Cable Company used this GMC school bus to provide transportation between home and work for employees. Above the company name on the side of the bus were the words "War Industries Transport."

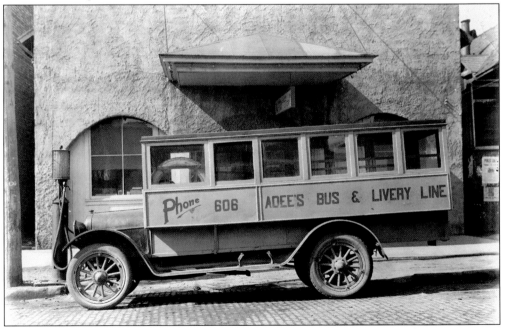

In the 1920s, Charles Adee had a garage business on the west side of California Street a half block south of State Street. He also operated a Sycamore to DeKalb bus line, providing residents with an alternative to the streetcar. As posted on the bus, this was the era of three-digit telephone numbers.

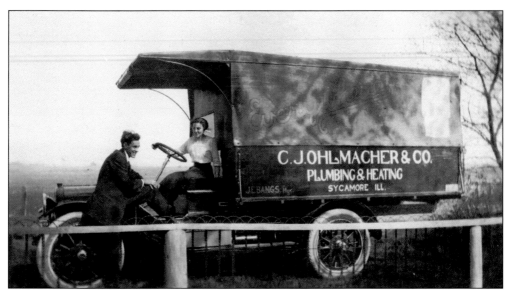

Christian J. Ohlmacher established his own business in 1897 after working for H. C. Whittemore for 20 years. He was successful enough to eventually build a business block adjoining the Elks lodge building for his plumbing and heating firm. James E. Bangs, Ohlmacher's manager, and his unidentified companion at the wheel show off the company's state-of-the-art truck in this undated photograph.

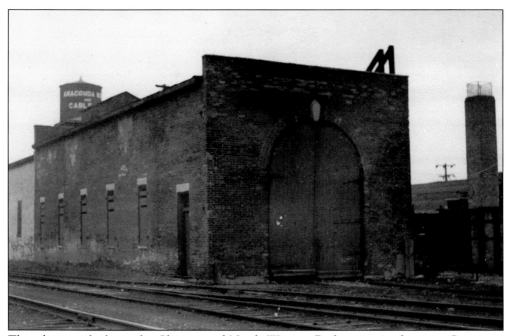

This photograph shows the Chicago and North Western Railway engine house in Sycamore. The engine house was attached to the north end of the old Marsh Harvester Works factory to enable the engines to get water and steam from the building's power plant. Anaconda Wire and Cable Company was making use of the building when the photograph was taken in 1920.

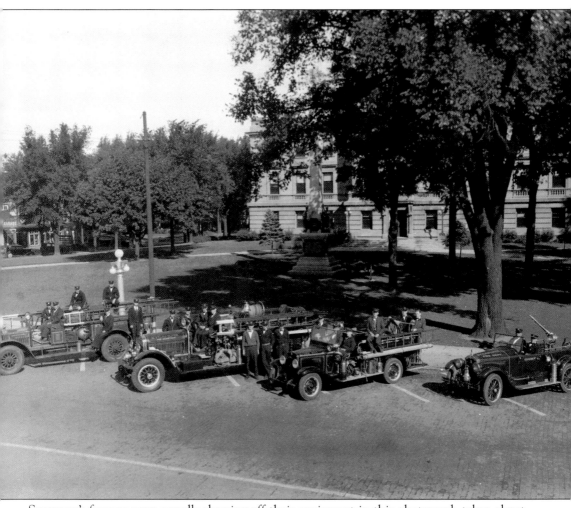

Sycamore's firemen were proudly showing off their equipment in this photograph taken about 1928. The Clydesdale unit (far left) was the department's first motorized truck, purchased in 1919. The Stutz engine (second from left) was purchased in 1923. Chief Charles Butzow is at the wheel in his car at the far right.

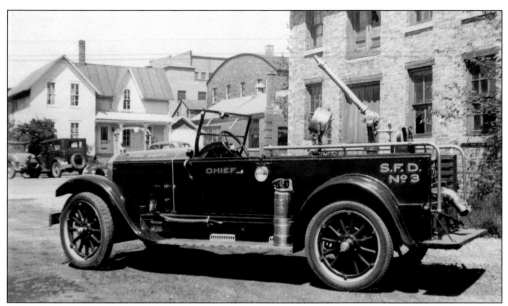

In 1919, Sycamore contracted with the Butzow Brothers Garage to provide fire protection for a $150 per month fee. The Butzows stored and maintained the city's new pump and ladder truck and also provided the city with manpower for fighting fires. This unique arrangement captured so much attention it was written up in *Popular Mechanics* magazine in 1921. Charles "Chick" Butzow served as Sycamore's fire chief from 1919 until he retired in 1952. This close-up of his truck with the "chief" designation on the door was taken in 1935.

LOCATION OF
FIRE ALARM BOXES

12	Main Street and C. G. W. Ry
13	Sabin and E. Exchange Sts.
14	Sycamore and Walnut Sts.
15	State and Locust Sts.
16	Elm and Governor Sts.
17	High and Locust Sts.
21	Sycamore and California Sts.
22	N. California St. and North Ave.
23	State and California Sts.
24	State and Maple Sts.
25	High and Somonauk Sts.
26	Home and Main Sts.
27	Somonauk and Waterman Sts.
31	Southwest corner C. I. Wire factory
32	Mason Court and Loomis St.
34	State and Greeley Sts.
35	S. Cross St. and Center Ave.
36	DeKalb Ave. and Fair St.
37	State and Fair Sts.
41	DeKalb Ave. and Mill St.
42	Park Ave. and Ottawa St.
43	Edward and Harvester Sts.
45	S. Cross St. and Cottage Row
46	Park Ave. and Chauncey St.

On January 5, 1906, the first alarm using Sycamore's new fire alarm box system was turned in from box 23 at the corner of State and California Streets. The locations of the city's 24 fire alarm boxes are listed here.

Four

Sunday Worship and Book Learning

This photograph shows Sycamore's newly-erected Wesleyan Methodist Church in 1870. It stood at the northeast corner of California and Elm Streets, which still had the appearance of countryside. The Wesleyan Methodist denomination was established in upstate New York in the 1840s by Methodist Episcopalians who strongly objected to slavery and championed women's rights. With declining membership and financial difficulties, Sycamore's Wesleyan Methodists closed their church not long after repairs were made in September 1887.

The first floor of this house at 212 South Main Street was built in the mid-1850s as the Universalist church. When the congregation outgrew their small brick structure, they built a larger church on West State Street to replace it. Arthur Stark, secretary and treasurer of the Marsh Harvester Company, then added the second story and made this former church his home.

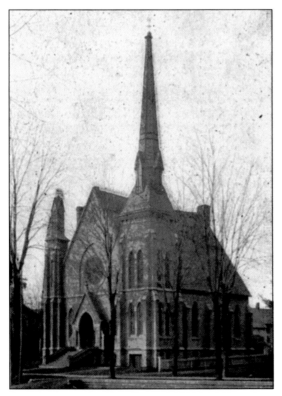

The Universalist congregation erected this church at 425 West State Street in 1875 at a cost of just over $11,000. The building was 38-by-74 feet, with a seating capacity of 300. Its landmark spire reached 112 feet. In 1927, the congregations of Sycamore's Universalist and Congregational churches merged and formed the Federated Church of Sycamore. This church building was then altered and converted into a community center.

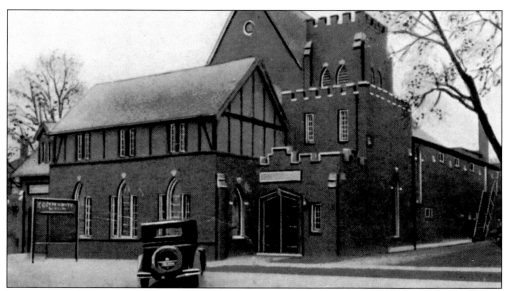

In 1928, the former Universalist church on West State Street underwent extensive renovation and expansion. It was converted into a community center funded by a $40,000 bequest from Mary E. Stevens and other donations. The spire and top of the east tower were removed, but the church bell was left inside the remaining lower tower. A swimming pool, bowling alley, auditorium, basketball court, and kitchen were in place at the Memorial Community Center when a week of dedication activities took place in October 1928. In 1954, a cement floor was poured over the swimming pool to create a room for dancing and other teen activities.

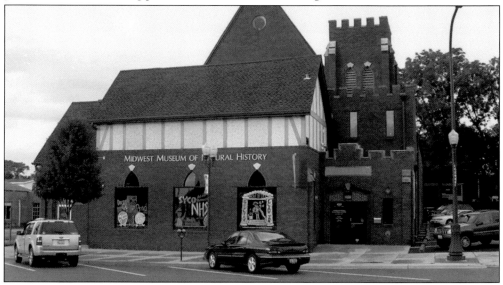

This former church and community center at 425 West State Street is now the Midwest Museum of Natural History. The offer of local residents Russell and Bernie Schelkopf to donate their extensive taxidermic collection was the catalyst for the museum's establishment. The city transferred ownership of the building to the Sycamore Park District in 2003. Following a $1.2 million renovation, the museum opened in February 2005. A building that once heard voices singing hymns now hears gleeful children checking out live spiders, snakes, and other creatures, and enjoying many hands-on activities.

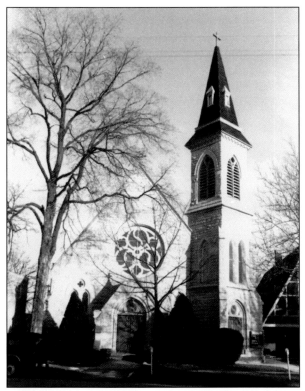

The St. Peter's Episcopal parish was organized in 1856, and in 1857, a church building was completed on Somonauk Street property donated by James S. and Abbie Waterman. In 1877, the cornerstone was laid for the present St. Peter's Episcopal Church at 206 Somonauk Street, shown in the photograph at left. The entire construction cost, estimated at $15,000 in an 1879 newspaper account, was funded by the Watermans. Architect George Garnsey designed the Batavia stone English Gothic–style building, which was consecrated on January 31, 1879. The interior photograph of St. Peter's was taken around 1900. This church, with its striking red door, is a Somonauk Street landmark.

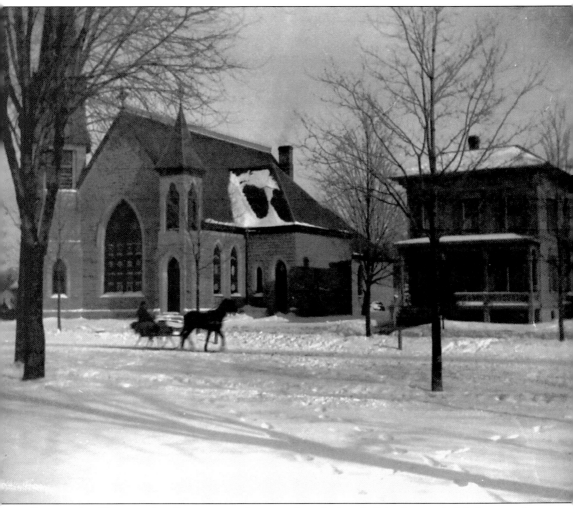

Sycamore's Congregationalists, once known for their abolitionist and Underground Railroad activities, began as a small group holding meetings in the courthouse in 1840. This Congregational church at 302 Somonauk Street was erected in 1884 and 1885. It replaced the congregation's first church building at the corner of North Main and East Exchange Streets. After the Congregationalist and Universalist Churches merged, their services as the Federated Church were held here from 1927 until 1963. This is now the home of the Sycamore Baptist Church. The house at right was the original parsonage, but it is now a private home.

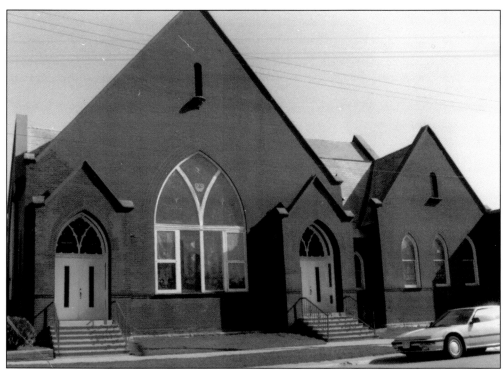

Constructed in 1899 as the First Baptist Church, this building at 131 West Elm Street replaced the congregation's original frame church at the same site. The Baptists worshiped here for nearly 100 years before moving to their new location at 530 West State Street in 1992. This building is now home to the Bethel Assembly of God congregation.

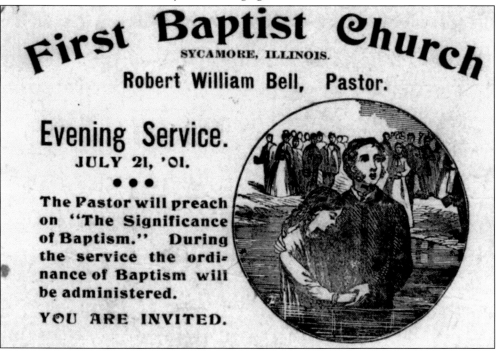

The African American congregation of the North Avenue Baptist Church had its start with 10 members meeting in a private home. Services at the congregation's first frame church building at the head of California Street began in 1909. This photograph shows the present church at 301 North Avenue, which was completed in 1945 under the leadership of the Reverend V. E. Harris.

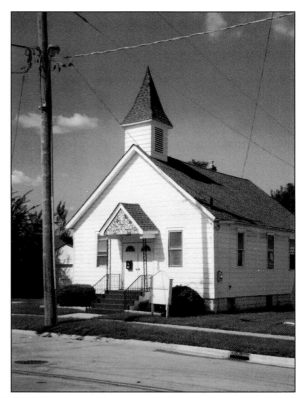

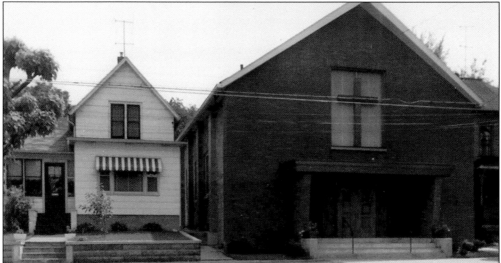

The Reverend George Flowers, born into slavery in 1854, was the founder of the Israel of God denomination. After organizing churches elsewhere, Flowers established his headquarters congregation in Sycamore. Temporary meeting places were replaced in 1910 when a barn was moved to North Avenue and reconstructed as a church. Flowers' successor, Bishop W. M. Jones, was pastor in 1953 when the present Israel of God Church at 248 North Avenue, at right in this photograph, was erected next to the parsonage. Delegates from several states have been traveling to Sycamore for the Israel of God annual conference since early in the 20th century. (Courtesy of Bob and Sue Rozycki.)

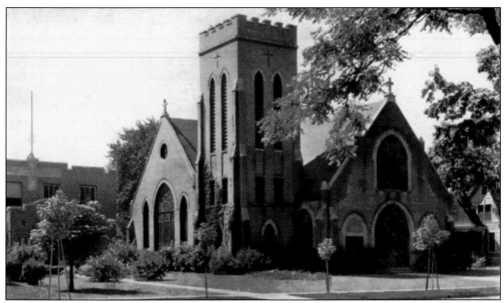

When the first Catholic church was built at the south end of California Street in 1862, it was the largest church building in the county. In 1902, the old church was razed, and the new Church of St. Mary shown in this photograph was constructed at the same location. It was built at a cost of $22,000, in the shape of a Maltese cross and made of pressed brick and Bedford (Indiana) stone in the English Gothic style. There is a partial view of St. Mary's Catholic School at left in the background. (Courtesy of the Church of St. Mary archives.)

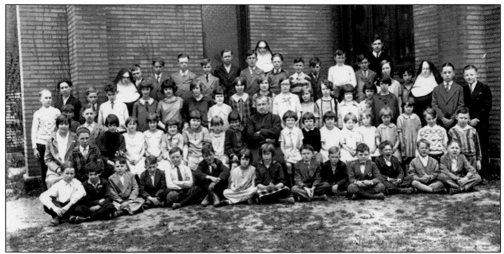

The year 1924 was a memorable one for Catholic families in Sycamore when St. Mary's Catholic School was built on Waterman Street between St. Mary's Church and the original rectory. The new school, with four classrooms and an auditorium, opened in August 1924 with an enrollment of about 70 pupils. Nuns from the Sisters of Mercy were in charge of classes, one of whom taught music, including piano, voice, and violin. The old Methodist parsonage on the corner of Somonauk and Waterman Streets was purchased for use as a convent. Four classrooms and office space were added to the school in 1960. Lay teachers and a lay principal now continue the Catholic education tradition. This 1926 photograph of St. Mary's students was taken outside the church. (Courtesy of the Church of St. Mary archives.)

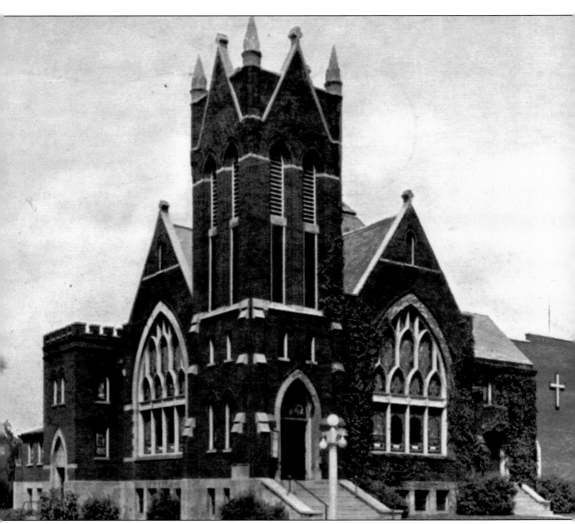

This Gothic-style Methodist Episcopal church with a seating capacity of 1,000 was erected at 129 Somonauk Street in 1908. It was the third church built by the Methodists on land donated by Carlos Lattin, one of Sycamore's first settlers. Sycamore's Methodists worshiped here until services were moved to the new church at 160 Johnson Avenue in 1977. This brick building was razed, and the site at the northwest corner of Somonauk and Elm Streets is now a city parking lot.

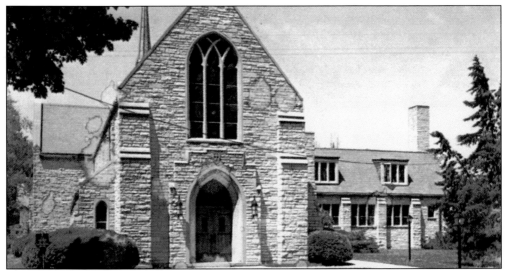

After meeting for worship services in the jury room of the county courthouse for several months, the German Lutheran Society was organized in 1876. In 1885, the former Congregational church at North Main and Exchange Streets was purchased by the society for $1,300. The St. John's Lutheran Society of Sycamore, as it was later known, worshiped there until 1938. After church member Paul A. Nehring donated two lots at the northwest corner of Main and Ottawa Streets along with $50,000 for construction, the church shown here was erected. The Evangelical Lutheran Church of St. John, the name adopted by the congregation in 1950, held services here from 1938 until early 2004.

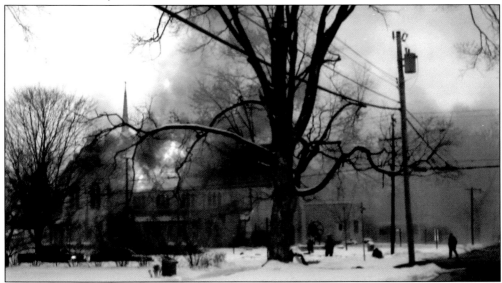

This photograph was taken on February 9, 2004, during the devastating fire that destroyed the 1938 Evangelical Lutheran Church of St. John structure at 327 South Main Street. A small fire, which started when the church organ's blower malfunctioned, led to the largest incidence of back draft ever recorded in the country. A new St. John church building, constructed at 26555 Brickville Road, was dedicated on April 29, 2007. The former church property on Main Street was purchased by the Sycamore Park District, which in 2007 announced plans for the Charlie Laing Memorial Park on the site.

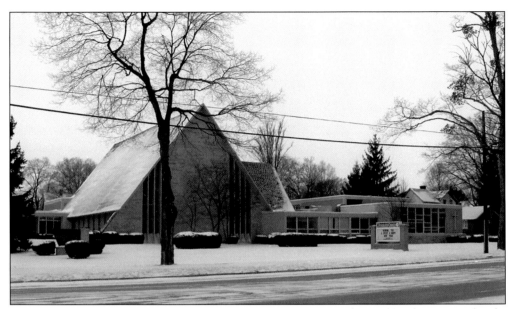

The first services at this Federated Church, located on property donated by the Dutton family, were held on February 23, 1963. This modern 20th-century structure at 612 West State Street was strikingly different from the congregation's former, nearly 80-year-old church on Somonauk Street. The Federated Church is affiliated with the United Church of Christ and the Unitarian Universalist Association, a continuation of its historical origins as the combined Congregational and Universalist denominations.

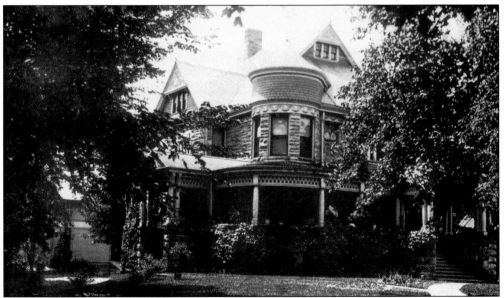

This landmark Sycamore mansion stood on a 225-by-327-foot lot at the corner of West State and Greeley Streets. The gray stone home with a large wood veranda was erected for Civil War general Everell F. Dutton in 1870. The general's son, banker George E. Dutton Sr., and his wife, Jane, later made this their home. In 1956, their four children memorialized their parents by giving the property to the Federated Church. The house was razed before construction of the Federated Church began in 1961.

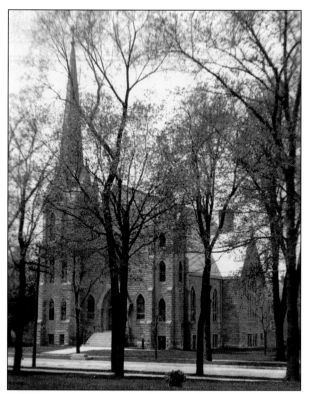

In 1870, about 50 of Sycamore's Swedish immigrants formed the Swedish Evangelical Lutheran congregation, later renamed Salem Lutheran Church. In 1896, the stone church in this photograph was erected on the corner of Charles and Somonauk Streets, where the parsonage for the congregation's smaller 1874 church had stood. Church services were conducted in Swedish until 1921. In 1938, a "singing tower" was installed to replace the chimes of the church's damaged bell. In 1970, the congregation's centennial year, the current Salem Lutheran Church at 1145 DeKalb Avenue was erected.

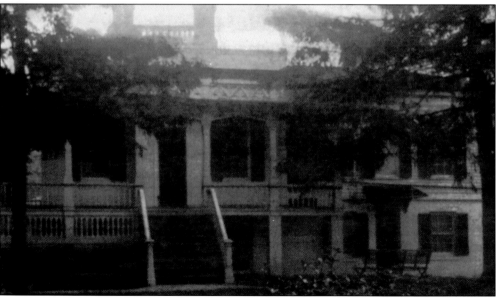

Roswell Dow taught public school students in the 1847–1848 winter term and then started a select (private) school. After holding classes at the courthouse and the Sons of Temperance hall, in 1850 he erected this residence and school commonly called Dow's Academy. The academy also housed public school students in 1853 before the city built its first schoolhouse. After Dow discontinued his school in 1853, he held office as township assessor and two terms as county treasurer. Maj. John W. Burst, a Civil War veteran, later made this his home.

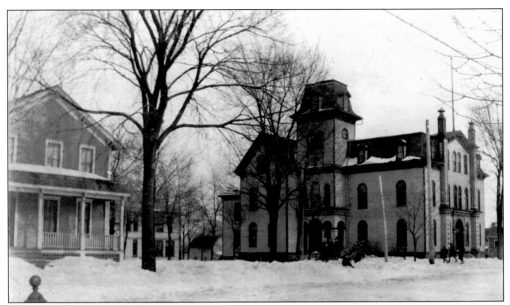

In 1853, Carlos Lattin's lot at the northeast corner of California and Exchange Streets was purchased for $100 as the site for the first public school building erected in Sycamore. After the second school there burned in 1863, this larger frame building (right) was constructed at the same site. This first Central School contained eight classrooms, cloakrooms, recitation rooms, an apparatus room, and an assembly hall on the top floor. All Sycamore students from grade one through high school attended here until an additional primary school (West School) was built in 1877.

Sycamore's first West School was this two-room, two-story, frame schoolhouse constructed in 1877 on the west side of Cross (now Center Cross) Street. It was also called the Third Ward School. The structure, considered a fire trap, was replaced in 1910. The second West School was a two-story brick building with four classrooms, located at Roosevelt Court and Alma Streets. This is an original drawing by Robert J. Myers.

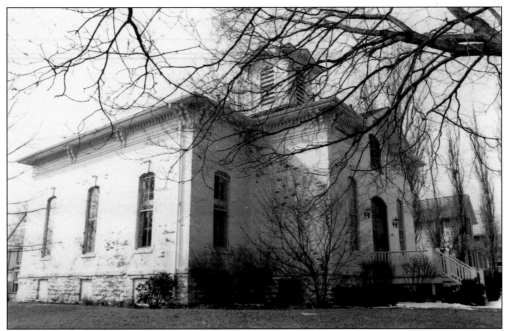

East School was erected as a two-room primary school in 1880. Sycamore school historian Andrew J. Blanchard described this brick Italianate building as "an ornament to that section of the city, and a model of comfort and convenience." The old school at 410 Elm Street was converted into a two-story private residence in 1976.

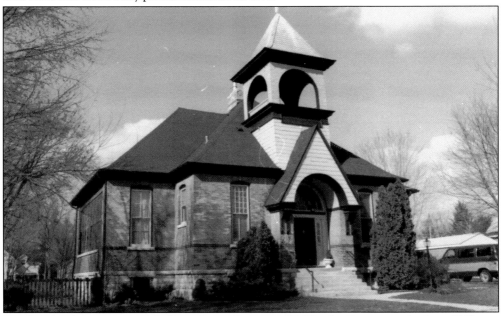

South School, now a remodeled private residence at 417 Charles Street, was built in 1897 as a two-room primary school. Elementary classes were taught here until 1959. From 1962 to 1967 Sycamore's first Opportunity House training center for the developmentally disabled was housed here. After brief use by the school district for special education classes, "Old South" was sold at auction for $9,100 in 1972.

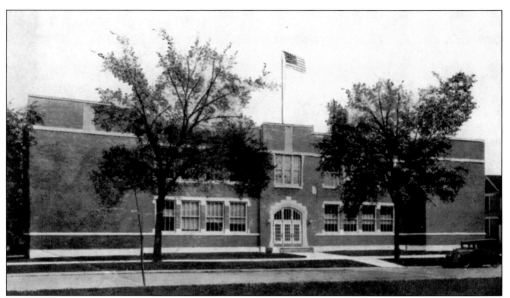

This third Central School building at 245 West Exchange Street opened in 1927, just a year after fire destroyed the second Central School. This building stands where the 1863 frame Central School had been, and just south of the site of the burned-out 1899 brick building. A gymnasium on the first floor and rooms for domestic science and sewing, manual training, and a library on the second floor were included. Today this building houses the administrative offices of Sycamore Community Schools.

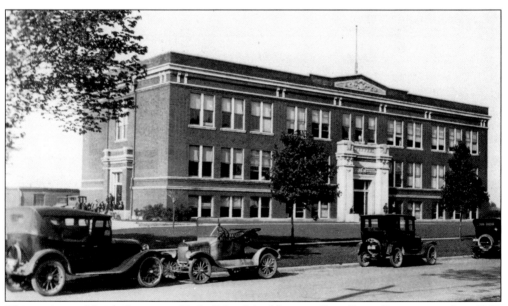

This variegated brick Sycamore High School building on East State Street opened in 1917. Unlike the 1899 Central School that high school students had been attending, the new five-acre campus had enough space for athletic fields. Students attended high school here for over 40 years until the current building on Spartan Trail was constructed in 1960. Following use as a junior high for a number of years, the old school that held so many memories was sold at auction in 1980. It was later demolished and replaced by a supermarket and parking lot.

COURSE OF STUDY ADOPTED BY SYCAMORE SCHOOLS.

The fall term will begin September 5. There will be little change in the text books, but the changing from a three years to a four years course necessitates the addition of the following books: Wentworth's Geometry, Colton's Pratical Zoology, Fiske's Civics, Remsen's Laboratory Manual in Chemistry, Montgomery's English History.

LATIN COURSE.

	FIRST TERM	SECOND TERM	THIRD TERM
First Year	Latin Algebra Physiography English	Latin Algebra { Physiography ½ { Physiology ½ English	Latin Algebra Physiology English
Second Year	Cæsar & Latin Comp. Geometry Zoology English	Cæsar & Latin Comp. Geometry { Zoology ½ { Botany ½ English	Cæsar & Latin Comp. Geometry Botany English
Third Year	Cicero & Latin Comp. Chemistry General History English	Cicero & Latin Comp. Chemistry General History English	Cicero & Latin Comp. Chemistry General History English
Fourth Year	Vergil's Aeneid Higher Algebra Physics English	The Aeneid { Higher Algebra ½ { Solid Geometry ½ Physics English	The Aeneid Solid Geometry Physics English

Music and Rhetorical Work in all Courses.

ENGLISH COURSE.

	FIRST TERM	SECOND TERM	THIRD TERM
First Year	Latin Algebra Physiography English	Latin Algebra { Physiography ½ { Physiology ½ English	Latin Algebra Physiology English
Second Year	English History Geometry Zoology English	English History Geometry { Zoology ½ { Botany ½ English	Book-keeping Geometry Botany English
Third Year	Civics & American His. Chemistry General History English	Civics & American His. Chemistry General History English	Civics & American His. Chemistry General History English
Fourth Year	Political Economy Physics Higher Algebra English	General Reviews Physics { Higher Algebra ½ { Solid Geometry ½ English	General Reviews Physics Solid Geometry English

Music and Rhetorical Work in all Courses.

When Sycamore High School converted from a three-year to a four-year curriculum, this new course of study was printed in the August 20, 1898, issue of the *True Republican* newspaper.

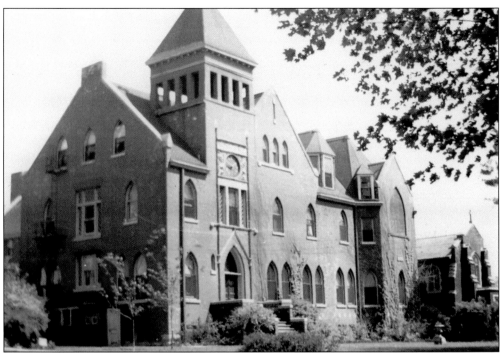

From 1889 until 1967, the massive bell tower of Waterman Hall (above) dominated the south side of Sycamore. Abbie Waterman provided in her will for the establishment and endowment of an Episcopal girls' boarding school on 60 acres of the Waterman farm along Somonauk Street. The farmhouse of the old homestead (below) became the school's rectory. Waterman Hall, a fashionable girls' finishing school for 28 years, closed after the 1918 commencement due to falling enrollments in the World War I era.

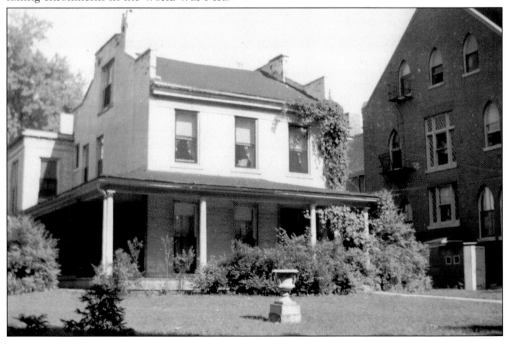

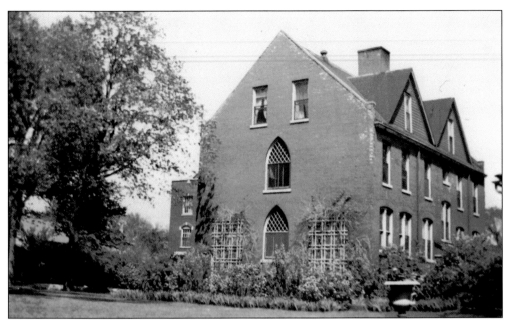

Shown in the above photograph is the 1890 building that was the second of five erected for Waterman Hall. The photograph below shows a view of the pleasant wooded grounds of the school. In 1919, St. Alban's School for Boys, an Episcopal boarding school in Knoxville, Illinois, moved to the Waterman Hall facilities. After operating at a loss during the Depression years, St. Alban's closed its doors in 1938. Government agencies such as the New Deal's National Youth Administration later made use of the facilities for training. From the late 1940s until 1963, the Episcopal Diocese of Chicago operated the remaining 12.5-acre campus as the Bishop McLaren Center, a place for retreats, conferences, and training. The buildings met the wrecking ball in early 1967, making way for St. Alban's Apartments.

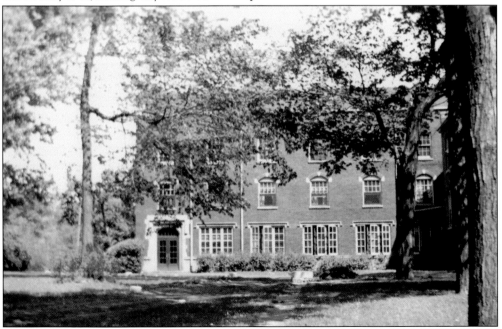

Five
MADE IN SYCAMORE

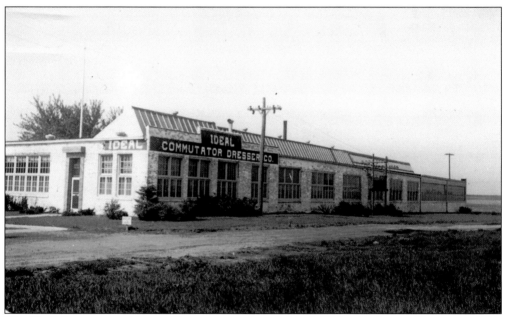

The Ideal Commutator Dresser Company was founded by J. Walter Becker in Chicago in 1916. Lou C. Becker joined his brother as a partner a short time later. The original product was an abrasive dresser stone used to resurface electric motor commutators. In 1924, the company moved to Sycamore, locating five employees in a small downtown State Street building. It revolutionized the electrical industry with the first screw-on wire connector in 1928. The name Ideal Industries Incorporated was adopted in 1946 when the partnership became a corporation. Still headquartered in Sycamore, today the company has manufacturing facilities in several locations, does business in 88 countries, and sells a product line of over 6,000 items. The company's 1939 facility is shown in this photograph.

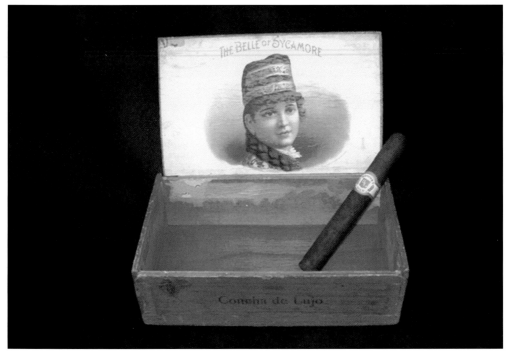

In 1891, Eugene C. Chandler opened a cigar factory and retail store across from the courthouse at 134 West State Street. By 1897, Chandler employed nine union cigar makers who earned $2.50 per day paid in gold and produced nearly 50,000 cigars each month. This cigar box held Chandler's Belle of Sycamore brand. Cuban Rays, La Reflections, and Stockyard Zephyrs were also sold. The business closed shortly after World War I in an era when less-bulky cigarettes were increasingly popular.

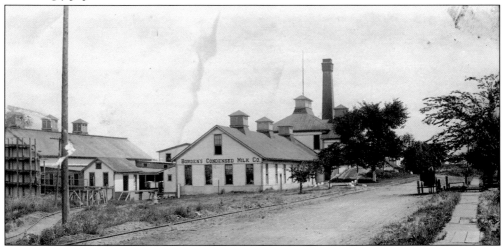

The Borden Milk Plant, which opened in 1907, was a thriving industry until 1932. Milk hauled to Sycamore in large metal cans from area farms was poured into a large tube accessible by an outside ramp and then carried inside the plant by gravity. The milk was packaged in glass bottles. A grass fire that started along the nearby Chicago and North Western Railway tracks spread and destroyed the facility in 1932. The plant was not rebuilt, but the name survives in Borden Avenue.

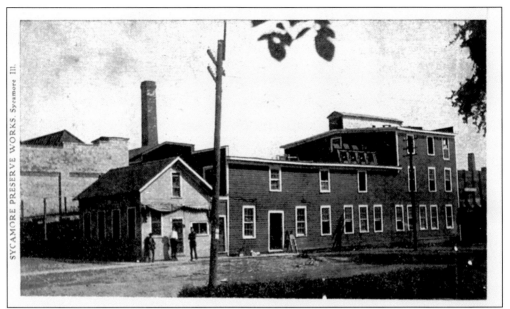

The Sycamore Preserve Works Corporation was established around 1882. In addition to canning at the plant, the company rented farmland where the peas, corn, beans, asparagus, and other vegetables were raised by its employees. The best-known label produced was Crescent. Other brands were White Lily, Elkhorn, and Birchbark. During World War II, German prisoners of war were part of the factory labor force. This building at 304 Harvester Street was razed in 1977.

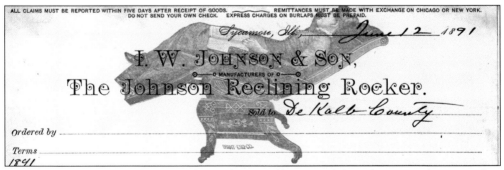

The letterhead of I. W. Johnson and Son shows a silhouette of the Johnson Reclining Rocker. This easy chair, patented by Isaac W. Johnson in 1887, was manufactured in Sycamore. The chair stretched into a lounge chair and reconverted without effort into an easy chair that could be stationary or a rocker. In 1886, the reclining rocker cost from $8 to $12.

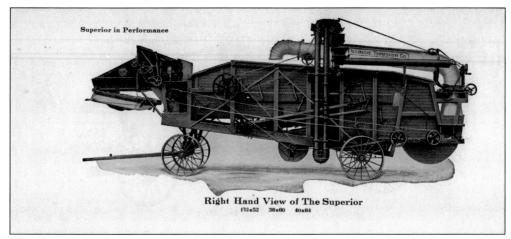

The Illinois Thresher Company manufactured a combined separator and huller, an innovation for its ease of use. In later years, the company was known for the manufacturing of steam and gas engines in addition to agricultural machinery. William N. Rumely of LaPorte, Indiana, founded the company in Sycamore about 1914. It was located on the west side of Park Avenue and occupied buildings from the former Marsh Harvester Company, R. Ellwood Manufacturing Company, and the Frank C. Patten's Sycamore Foundry Company. This drawing from the company's catalog shows the right-hand view of the Superior model.

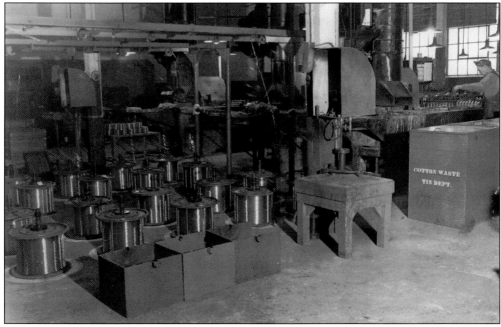

In 1890, the Chicago Insulated Wire Company moved to Sycamore. The original product was a copper wire wrapped in cotton braid, saturated in asphalt, and covered with finishing wax to make a weatherproof wire. By 1917, Chicago Insulated Wire Company was said to be able to produce about 400 varieties of wire. In 1929, the company merged with other wire-producing companies to form Anaconda Wire and Cable Company. Anaconda was a major local industry until the factory at 421 North California Street closed in January 1983. This photograph shows employee Charles Korleski preparing to tin copper wire.

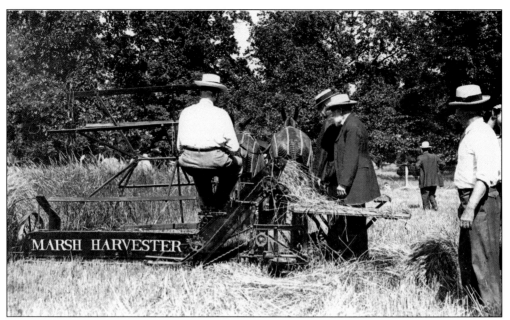

A Marsh Harvester is shown in this photograph. Two men rode standing on a platform on the side of the machine and bound the grain as it came up. This process was faster and took less manpower than previous equipment. The device was patented by brothers Charles W. and William W. Marsh in 1858. Initially the harvesters were manufactured in Plano, but in 1869, the brothers built the Marsh Harvester Manufacturing Company in Sycamore. The factory was the largest in the area for many years. In 1882, after several years of financial problems, the company reorganized as the Marsh Binder Manufacturing Company. Two years later the business went bankrupt.

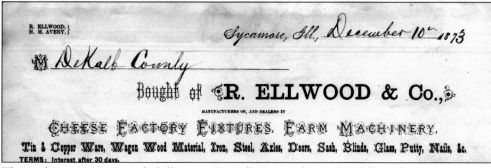

This is the upper portion of a bill sent to DeKalb County by Reuben Ellwood's company. It lists the many products available in 1873.

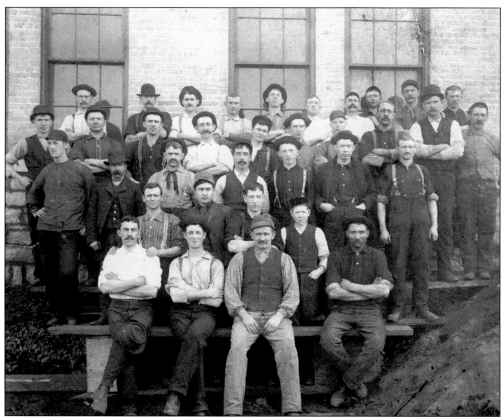

These men were employed by Frank C. Patten at his Sycamore Foundry Company. In 1893, Patten purchased and consolidated the former Marsh Harvester and Reuben Ellwood plants to form this new enterprise. Expanding beyond farm implements to such products as gasoline engines, hot air furnaces, and blacksmith's tools, Patten had increased the workforce from 35 to 175 by 1907. Blumen Gardens is now housed in part of the old factory complex.

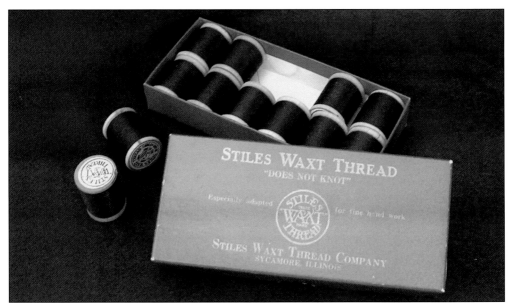

Stiles Waxt Thread was invented by Mary B. Stiles in 1905 in Chicago. The thread was popular with quilters from coast to coast as it did not tangle or knot. Stiles and her son, Aaron K., moved the business to Sycamore in 1924. The family retained ownership until 1965 when Martha McCabe purchased the business. The business was later owned by Nora and Jack Hartman. When plastic spools replaced wooden ones, the business closed. The plastic spools were not compatible with the thread waxing process.

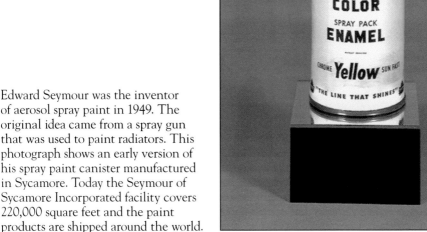

Edward Seymour was the inventor of aerosol spray paint in 1949. The original idea came from a spray gun that was used to paint radiators. This photograph shows an early version of his spray paint canister manufactured in Sycamore. Today the Seymour of Sycamore Incorporated facility covers 220,000 square feet and the paint products are shipped around the world.

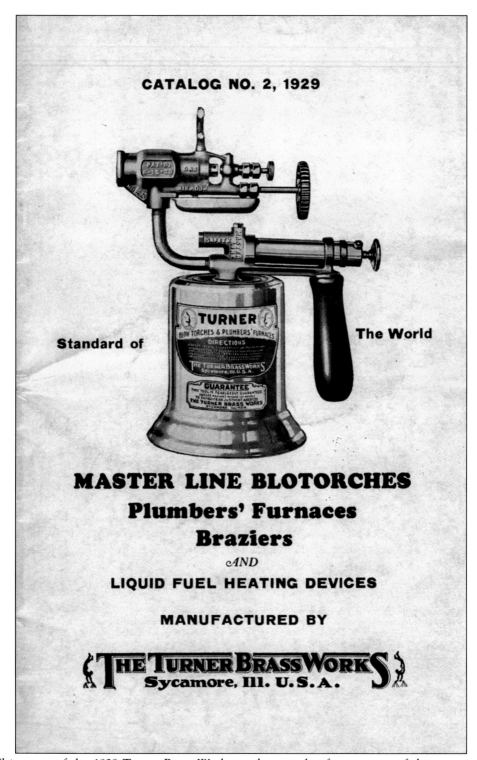

This cover of the 1929 Turner Brass Works product catalog features one of the company's blow torches.

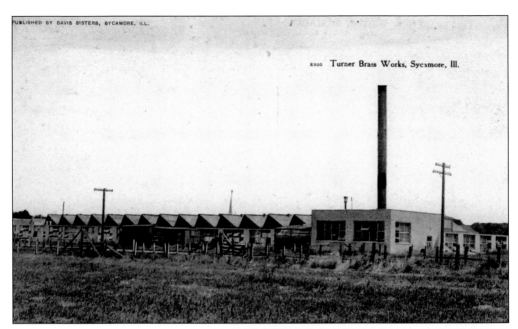

Turner Brass Works moved from Chicago to Sycamore in 1907, locating in the industrial complex on the south side of town. Adm. Richard E. Byrd carried Turner blowtorches and firepots with him on the 1933–1935 Byrd Antarctic Expedition. In addition to making several types of fuel appliances, the Turner product line included tubular brass fixtures, fittings, and trim items. The company was selected to manufacture over 5,000 torches for the relay to the 1984 Summer Olympics in Los Angeles. Two Sycamore men, Tony Young (right) and Paul O'Neal, were part of that relay. Cooper Tools bought Turner Corporation in the early 1980s and announced in late 1998 that the plant would be closing early the next year.

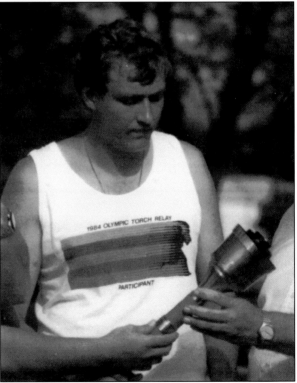

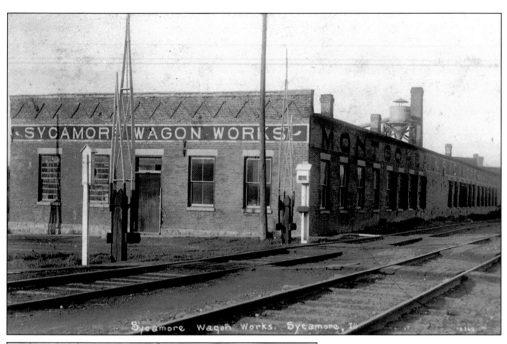

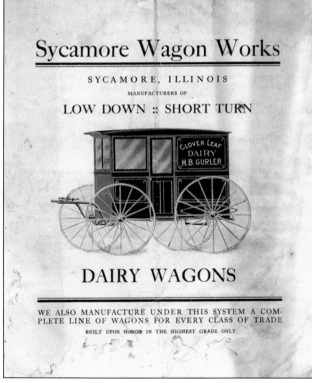

This building housed the Sycamore Wagon Works. Articles of Incorporation were issued in 1904 to the Sycamore Wagon Works with stock worth $60,000. There were 15 men on the payroll. In 1912, the company moved to DeKalb. The empty building later became a warehouse for Montgomery Ward and Company. The catalog cover (left) features a dairy wagon made for H. B. Gurler's Clover Leaf Dairy in DeKalb. (Courtesy Bob and Sue Rozycki.)

Six
Leading Ladies and Gents

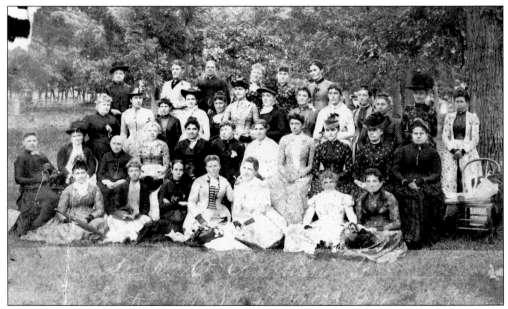

This photograph was taken at a Woman's Relief Corps picnic. Wives, mothers, daughters, and sisters of Civil War veterans organized a branch of the Woman's Relief Corps, which was an auxiliary of the GAR, in Sycamore in 1886.

Dr. Letitia Westgate, daughter of a LaSalle County farmer, was the first woman physician in Sycamore. She graduated from Northwestern University Women's Medical School. Her first offices were on West State Street. In 1900, Westgate opened a hospital, a three-story building on the corner of Somonauk and Elm Streets. This was the first hospital in the state operated by a woman. A slander suit, financial difficulties, and bad publicity forced the closing of the hospital in 1907. Westgate moved to Aurora where she worked as a chemist for the city health department.

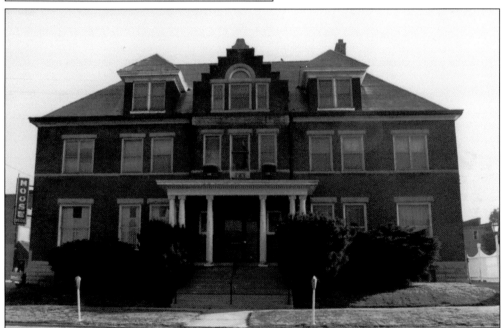

Sycamore's first hospital, designed by Westgate, opened in 1900. It had steam heat, electricity, running water, and telephones. Over the years since its 1907 closing, the building has housed a hotel, a boardinghouse, the Elks and Moose lodges, the Sycamore Historical Society Museum, the Sycamore Chamber of Commerce, and an art school.

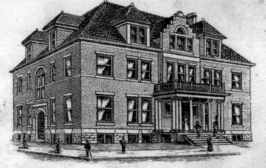

...Sycamore Hospital,...

Dr. Letitia A. Westgate, House Physician and General Manager.

TELEPHONE: CENTRAL UNION 13, DE KALB CO., 8.

Sycamore, — — — — Illinois.

The front and back of Westgate's business card are shown here.

RATES:

Ward Beds per week ... $15.00
Private Rooms per week $20.00 to $35.00
Special Nurse per week $10.00
Surgical Cases—Use of Operating Room, Necessary
 Preparation and Surgical Dressings $5.00 or more.
(Payable weekly in advance.)

All reputable physicians and surgeons are welcome to the privileges of the Hospital and are assured of the privacy and comfort of their patients.

Any member of the Sycamore Hospital Association can have his stock redeemed at par by sending a patient to the Hospital; one-half the fee will be used in purchasing said stock. Respectfully.

DR. L. A. WESTGATE,
House Physician and General Manager.

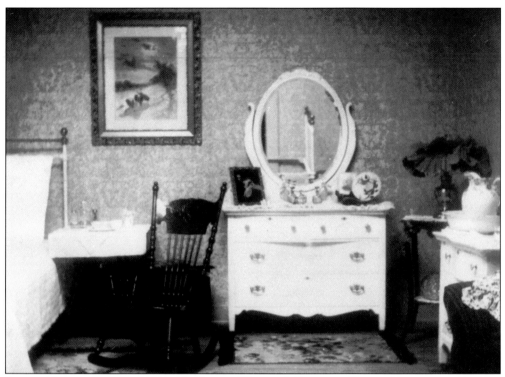

Pictured here is a private room at Dr. Letitia Westgate's Sycamore Hospital.

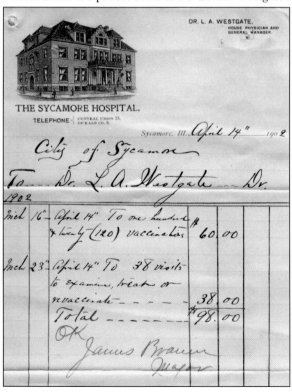

Westgate sent this bill for smallpox vaccinations to the City of Sycamore.

Sisters Edna and Ella Davis were the first women to have a business in downtown Sycamore. For 32 years, they owned and operated a book and stationery store at 321 West State Street. Both were graduates of Valparaiso University and members of the Illinois Press Association. They also conducted a prosperous real estate business. Here is an example of the penny postcards the sisters had printed and sold at their store.

WARMEST AND DRYEST.

March Just Closed Broke All Records In Both Respects.

Weather report for March, 1910, as kept in Sycamore, Ill., by Edna J. Davis, official observer:

Highest temperature 84 on the 24th, 29th and 30th; lowest 13 the 1st; range 71; greatest daily range 47 the 24th; least 13 the 2nd and 15th; mean for the month 45.4, which is the highest mean ever recorded here. The lowest mean was 26.4 in 1885.

The prevailing wind was southeast. Total precipitation was 23 hundredths of an inch which is the least ever recorded here; the greatest was 4.85 inches in 1882. Rain fell on one day only and the greatest in any 24 hours was .23 the 19th. There were 21 perfectly clear days, 10 days when the morning was cloudy but the sun came out some time during the day. There was a thunderstorm the 19th. A dense fog the 2nd, 4th, 5th and 6th.

Edna also worked as a correspondent from DeKalb County for the *Chicago Herald*, *St. Louis Post Dispatch*, *Rockford Star*, and Sycamore *True Republican*. In 1910, she was the official weather observer in Sycamore, reporting the monthly precipitation, prevailing winds, and high and low temperatures to the local newspaper. After Edna's death in 1916, older sister Ella continued in business until she died in 1921.

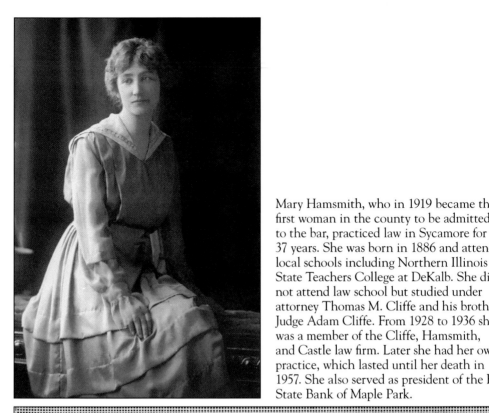

Mary Hamsmith, who in 1919 became the first woman in the county to be admitted to the bar, practiced law in Sycamore for 37 years. She was born in 1886 and attended local schools including Northern Illinois State Teachers College at DeKalb. She did not attend law school but studied under attorney Thomas M. Cliffe and his brother Judge Adam Cliffe. From 1928 to 1936 she was a member of the Cliffe, Hamsmith, and Castle law firm. Later she had her own practice, which lasted until her death in 1957. She also served as president of the First State Bank of Maple Park.

PROFESSIONAL CARDS

T. M. CLIFFE **MARY HAMSMITH**

LAW OFFICES

SYCAMORE, ILLINOIS

CLIFFE BUILDING **PHONE 93**

This is a portrait of Georgiana Beard, whose wedding was celebrated at the home of her father, Henry Beard. She married James F. Lucas of DeKalb on September 1, 1904. Henry, a former slave, was mustered into Company A of the 105th Illinois Infantry Regiment in Tennessee in 1863. He served as a cook with the DeKalb County troops. After the Civil War, he settled north of Sycamore with his wife, Judy Jones, also a former slave. Georgiana and her siblings attended the one-room North Grove School with the neighboring Swedish immigrant children and learned to speak Swedish when it was the official language of that school.

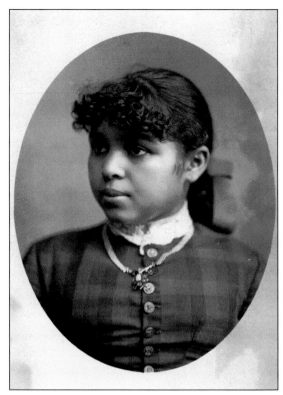

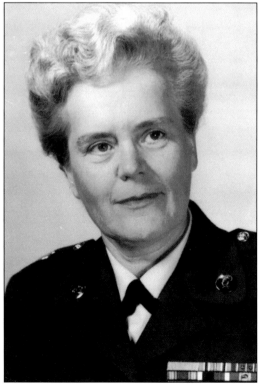

M.Sgt. Esther Mae Nesbitt, a talented local artist, enlisted in the Women's Army Corps (WAC) in 1943. On July 14, 1944 (38 days after D-Day), she was among the first 49 WACs to arrive in France, landing on Omaha Beach. Nesbitt, an intelligence analyst, became the custodian of all maps for the European Theater of Operations, with responsibility for keeping the war room maps up to date. For this, she became DeKalb County's only recipient of the French government's Croix de Guerre medal. After World War II, Nesbitt returned to Sycamore where, except for a return to military service during the Korean War, she lived until her death in 1971.

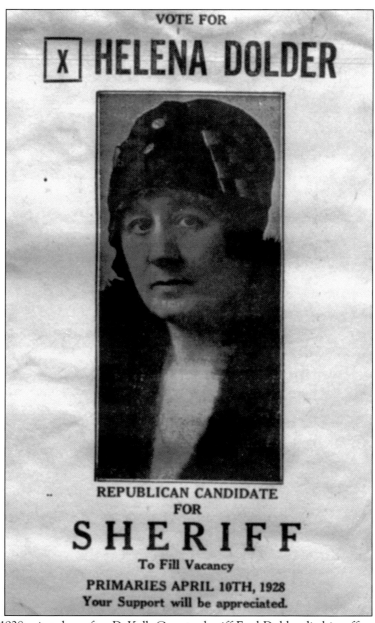

In January 1928, nine days after DeKalb County sheriff Fred Dolder died in office, the county board unanimously appointed his widow, Helena, to succeed him. She showed she could keep control of the jail when, on her first day on the job, 33 of her 92 prisoners rebelled over the food served for supper. She and her deputies turned fire hoses on them to gain control and sent them to their cells unfed. Many of the prisoners were bootleggers sent to Sycamore by federal courts. This stand by the state's only woman sheriff was front-page news in the *Chicago Tribune*. Her son Fritz, the chief deputy, slept in a room at the jail. After the "petticoat sheriff" hung lace curtains on his bedroom window, the county jail became known as the "lace curtain jail." Following a campaign that included this newspaper advertisement, Helena garnered more votes than her three opponents combined in the April primary. In November 1928, she was elected to complete the final two years of her husband's unexpired term.

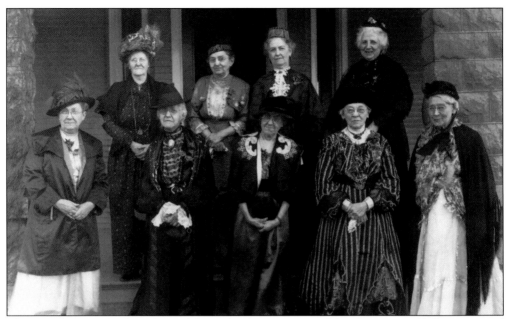

This is a photograph of members of the Columbian Literary Club. This group of ladies organized at the time of the 1893 Columbian Exposition in Chicago to meet and review books related to timely social topics. Pictured from left to right are (first row) Bess Crumb, Gertrude Whittemore, Nell Gates, Mary Townsend, and Mertie Simpson; (second row) Clara Holcomb, Louise Carlson, Laura Fulton, and Jennie Dutton.

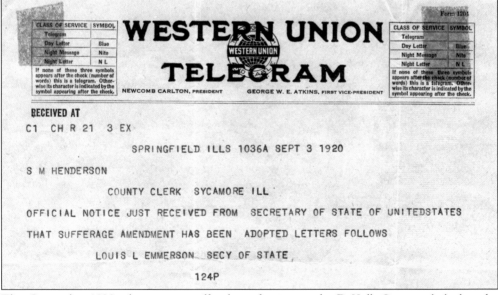

This September 1920 telegram gave official notification to the DeKalb County clerk that the 19th Amendment to the U.S. Constitution had been adopted. The amendment granted women citizens the right to vote for all offices. It arrived nearly 50 years after Susan B. Anthony spoke in Sycamore, and local ladies began campaigning for the vote. The telegram spells suffrage (which means "right to vote") incorrectly as "sufferage." Due to concerns about legal challenges, there were separate ballots for women in the November 1920 presidential election.

This collage shows the style of ladies' calling cards of the late 1880s. Married women's first names were never used.

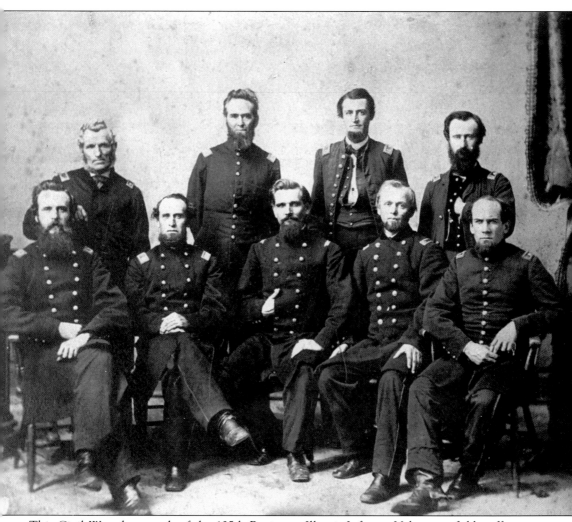

This Civil War photograph of the 105th Regiment Illinois Infantry Volunteers field staff was taken sometime between February 1863 and June 1864. DeKalb County men made up 6 of the regiment's 10 companies. Three of the men, Everell F. Dutton, Daniel Dustin, and Timothy Wells were from Sycamore. When the photograph was taken, Dustin was a colonel, Dutton was a lieutenant colonel, and Wells was a quartermaster. The Sycamore GAR post was named in honor of regimental surgeon Horace Potter, who was killed in battle in Georgia on June 2, 1864. Pictured from left to right are (first row) Everell F. Dutton, Henry Vallette, Daniel Dustin, Horace Potter, and Alfred Waterman; (second row) Daniel Chapman, Timothy Wells, David Chandler, and George W. Beggs.

Charles W. Marsh was 15 when his parents brought the family from Canada to settle on a farm near Shabbona Grove in 1849. He worked with his younger brother William on developing a harvester patent and on managing their Marsh Harvester Manufacturing Company in Sycamore from 1869 to 1884. In 1886, Charles was elected to the Illinois House of Representatives and later to the Illinois Senate. He also served as a trustee of the Northern Illinois Hospital for the Insane at Elgin for 25 years. Charles built a beautiful mansion on 20 acres that is now in DeKalb's Hopkins Park. After his death in 1918, the county purchased the property as the site of its tuberculosis sanitarium.

William W. Marsh, along with his brother Charles, established harvester manufacturing plants first in Plano and then, in 1869, in Sycamore. The younger brother of Charles by two years, William was the mechanical wizard of the family. At age 21, working on the family farm, he had the idea that led to inventing the March Harvester. He went on to develop a number of other patents. His 1872 home at 740 West State Street remains a Sycamore landmark. While involved with a business concern in Arkansas in the 1880s, William made profitable investments in timberlands. He died in 1918, five months before his brother Charles.

In 1837 at age 16, Reuben Ellwood came to Sycamore with his older sister Malinda and brother-in-law Joseph Sixbury. Before returning to New York after a few years, he was able to claim 160 acres of land. In New York he manufactured brooms and was elected to the state legislature in 1851. In 1857, Reuben returned to Sycamore and joined his brother Alonzo in the hardware business. After also engaging in the real estate business, he began the production of farm implements at his R. Ellwood Manufacturing Company in 1870. He became Sycamore's first mayor in 1869. Reuben was elected to the U.S. Congress in 1882. He was serving his second term when he died in 1885 and was honored with the largest Elmwood Cemetery procession seen to then. His obituary noted that he was the favorite brother in the Ellwood family.

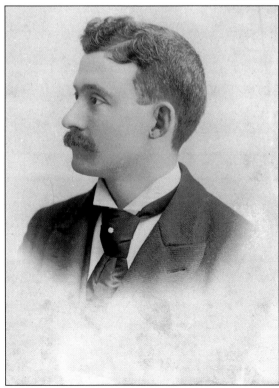

Frederick (Fred) Brundage Townsend (1858–1938), the oldest son of Amos and Eleanor Pierce Townsend, was born on a farm near Malta. After college, Fred began a banking career at Daniel Pierce and Company. The bank was owned by his grandfather. Fred was a civic leader in Sycamore in the early 20th century and was elected to several offices in spite of being a Democrat. He was a member of the county board of supervisors at the time the courthouse was built in 1903, and he served as an alderman and three-time mayor of Sycamore. At the time of his death, he was on the boards of both the Sycamore Public Library and the Sycamore Municipal Hospital. Always interested in farming, he owned land not only in DeKalb County, but in Iowa and Minnesota as well. He married Mary Boynton in 1890, and they were the parents of Charles B. and Eleanor, who married Thomas Roberts.

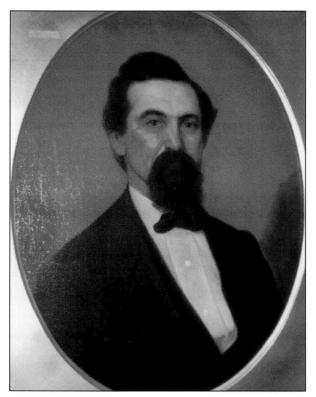

Born in Herkimer County, New Jersey, in 1823, Dr. Orlando M. Bryan came to Sycamore in 1846 where he began his medical practice in the young village. During the Civil War, he was commissioned by Pres. Abraham Lincoln as a brigade surgeon and reached the rank of brevet colonel. After the war, he was active in the growth of Sycamore. Dr. John W. Ovitz, his great grandson, practiced medicine in Sycamore 100 years after his pioneer ancestor.

County clerk Albert S. Kinsloe, a Civil War veteran, played a key role in Sycamore's retention of the county seat. A referendum on moving the county seat to DeKalb was to be held on November 4, 1902. Kinsloe, a Sycamore resident, intended to publish a notice the usual 30 days prior to the election, but then received a court order to desist on the basis that a 50-day notice was required. Responding to rumors that he had refused to hold the referendum, Kinsloe wrote a spirited defense stating, "Anything you may have heard to the contrary is as base, malignant, unscrupulous, devilish and unmanly a perversion of the real facts as it is possible to make. . . . Honesty of purpose I regard my most valuable asset and I have never and never will fritter it away by the willful performance of a wrong act or the disregard or neglect of a duty."

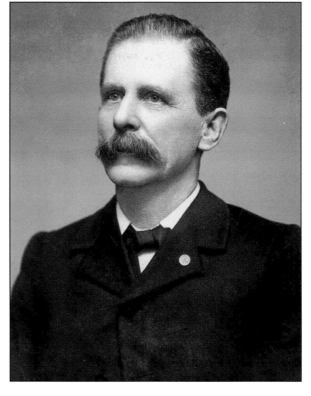

Deacon David West moved from Erie County, New York, to Sycamore Township in 1845. He purchased a farm on the eastern edge of the village. He became involved in Sycamore politics including county government and the organization of the DeKalb County Republican Party. He was a deacon of the abolitionist Congregational Church. West is best remembered for his association with the Underground Railroad movement and the special false-bottom buggy he built to move runaway slaves from his "station" to the next safe place east in Kane County. The final goal of the Underground Railroad was to deliver the runaway slaves to boats on Lake Michigan and freedom in Canada.

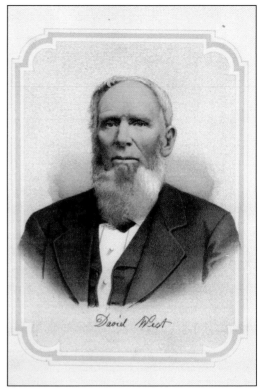

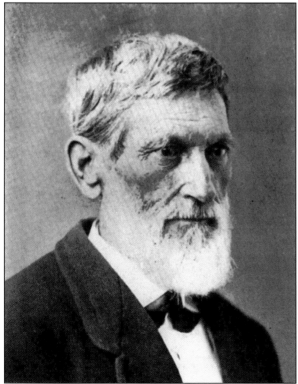

Jesse C. Kellogg, a native of Vermont, made his way to the area that would become Sycamore in 1835, and was chosen that year to be on the settlers' land claims committee that was formed to act until formal county government was in place. When DeKalb County was legally established in 1837, he became the first elected county recorder and the first county clerk. He later became Sycamore's first postmaster. His actions as a conductor of the Underground Railroad followed his beliefs as a deacon of the antislavery Congregational Church.

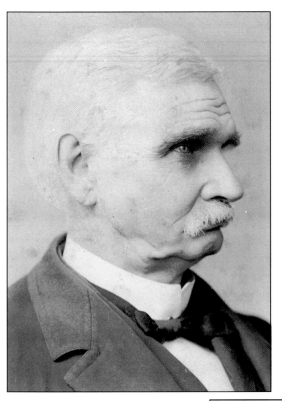

Born in Vermont in 1820, Daniel Dustin graduated from Dartmouth College in 1846 with a medical degree. He practiced medicine until 1850 when he decided to try his luck in the gold fields of the west. Interested in politics, he was elected to the state legislature as a representative of Nevada County, California. In 1858, he moved to Sycamore and joined the mercantile business of James E. Ellwood. He began his Civil War service with the 8th Illinois Cavalry (assigned to the Army of the Potomac) in 1861. In October 1862, he was placed in command of the new 105th Regiment Illinois Infantry with the rank of colonel. Dustin mustered out in 1865 at the rank of brigadier general. Returning to Sycamore, he served a total of 16 years in the county courthouse, first as county clerk, then as county treasurer, and in 1880 as circuit clerk and recorder. Dustin died in 1892 and is buried in Elmwood Cemetery among many of his Civil War comrades.

Born in New Hampshire in 1838, Everell F. Dutton came to Sycamore with his parents when he was eight years old. He grew up helping his father run a store and post office. He was working in the courthouse as deputy county clerk when the Civil War broke out, and he immediately enlisted in Company F, 13th Regiment Illinois Infantry as a first lieutenant. After transferring to the new 105th Regiment Illinois Infantry in 1862, he rose in rank from major to his final promotion as brigadier general in 1865. After the war, Dutton was elected to two terms as DeKalb County circuit clerk. He was president of Sycamore National Bank from 1883 until his death in 1900.

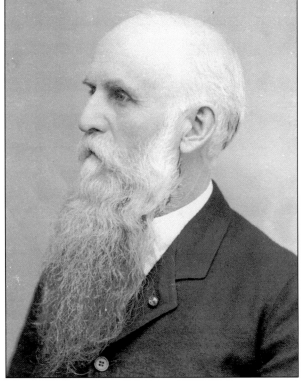

Born in Massachusetts in 1830, Henry L. Boies settled in DeKalb County in 1854. He spent time in farming and as a Sycamore postmaster, but found his true calling in 1863 when became a journalist with Sycamore's *True Republican* newspaper. Boies became editor and owner, and his 24 years of newspaper writing until his death in 1887 remain the primary source of Sycamore history for that period. This gifted writer published his *History of DeKalb County, Illinois,* a work of over 500 pages, in 1868. For all who have come after, Henry L. Boies is truly a "history hero." (Courtesy of John Boies.)

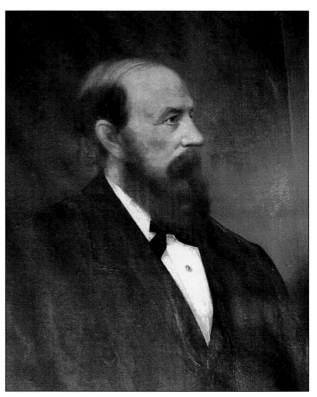

At age 22 in 1835, Carlos Lattin was the first settler on land that became part of Sycamore. His land holdings included most of Sycamore's future business district. His 1835 home was a log cabin built on the prairie 68 feet north of the present 307 West State Street. In 1844, he was elected county treasurer. Lattin was a successful grain and lumber dealer with considerable farmland. In 1858, he built his third and final home (now 305 Somonauk Street) on part of his original land claim. The first three Sycamore Methodist churches were built on Somonauk Street land donated by Lattin, who was a pillar of that congregation. He died in 1876 and is buried at Elmwood Cemetery.

James S. Waterman was one of Sycamore's pioneer settlers. Along with his brother, John, he opened the first general store in the new village. He was appointed deputy surveyor in 1839 and assisted Eli Barnes in the first platting of Sycamore. In 1857, he sold his stores in Sycamore and area settlements to concentrate on banking and his real estate holdings. In 1871, he founded Sycamore National Bank. Waterman was a key stockholder in the Sycamore, Cortland, and Chicago Railroad and in the Marsh Harvester and Reuben Ellwood factories. This benefactor of St. Peter's Episcopal Church died in 1883.

Reuben J. Holcomb (1839–1921) came to DeKalb County from New York with his parents in 1842. A veteran of the Civil War, he served as deputy sheriff under his brother Maurice. Later he was elected to four terms as DeKalb County sheriff. His ability as a detective was widely recognized. His brother Orator S. was also a sheriff of DeKalb County. Reuben also served as circuit court bailiff and constable.

This is a photograph of two pages from a journal that was kept by Rufus Hopkins, a young doctor born in New York. He practiced medicine in Sycamore for many years before moving to DeKalb in 1859. The journal has 390 pages and dates from 1848 through 1853. It lists his patients and the treatment given. He pulled teeth, dispensed cathartics (laxatives), tonics, bitters, and pills. The journal is literally a who's who of early Sycamore settlers and their ills.

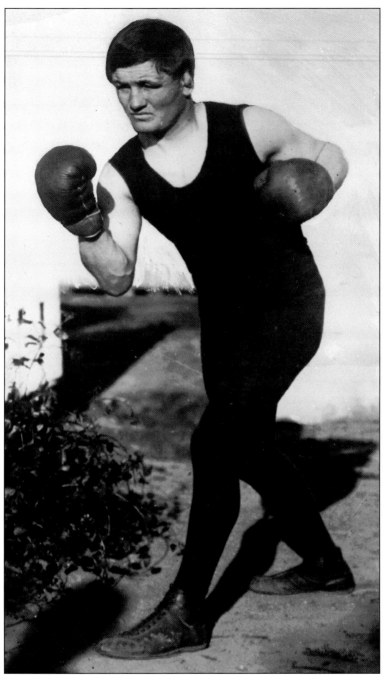

"Cyclone Johnny" Thompson grew up on a farm near Sycamore. As a young man, he frequented the local Stranglers Club gym. Standing only 5 feet 4 inches tall, he had a natural ability for boxing, and he discovered he could earn more in the ring than he could behind the plow. In 1911, Cyclone Johnny won the world's middleweight championship by beating Billy Papke in 20 rounds in Sydney, Australia. He hung up his gloves in 1913 and returned to his Sycamore farm. In 1942, he moved to town where he served for four years on the Sycamore police force, three of those as chief. Thompson died in 1951 but his legend lives on in Sycamore history.

Harold "Red" Johnson (left), with his sidekick Ole Halverson, was known for his wide-brimmed hat and auctioneer's cane after starting his auction business in 1956. Johnson began working at the Gullberg and Haines furniture store on Somonauk Street in 1946 and later became co-owner of the business with Chuck Gullberg. As Sycamore's mayor, Red became an institution, serving in that office from 1957 until his death in 1991. To speak with the mayor, whose first campaign slogan was "The Working Man's Friend," residents could just stop in at the furniture store and chat.

Clifford Danielson, fondly known as "Mr. D" came to Sycamore in 1926 to work as an assistant cashier at what was then known as the First Trust and Savings Bank of Sycamore. He later served as president of the bank. At the time of his death in December 1995, he was chief executive officer of the bank, which is now known as the National Bank and Trust Company of Sycamore. In 1988, the Sycamore Chamber of Commerce honored Danielson with its first outstanding citizen award and named it in his honor. He quietly contributed to the growth of Sycamore and he helped many men and women on their road to success. (Courtesy of the National Bank and Trust Company.)

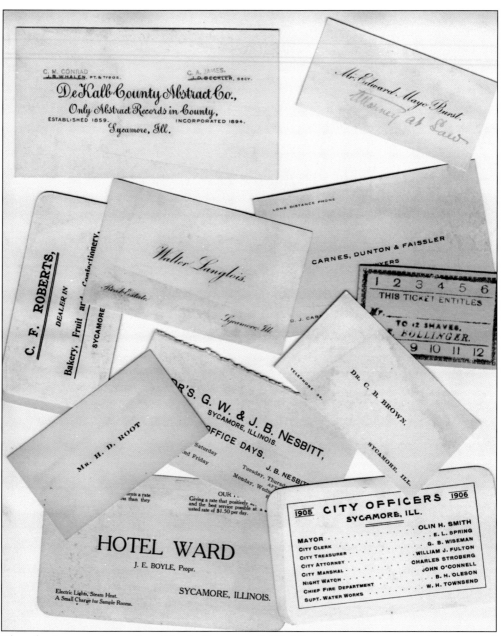

These business cards were found in the Sycamore Public Library cornerstone when it was opened as part of the library's centennial celebration in 2005.

Seven
LIFE OFFERS MORE IN SYCAMORE

In the spring of 1969, the Sycamore Chamber of Commerce arranged to have signs bearing its adopted slogan of "Life offers more in Sycamore" erected at five entrances to the city. The colorful signs, manufactured locally at Deco Porcelain, were finished in porcelain enamel. The process involved fusing glass to steel at a temperature of 1,550 degrees. The DeKalb-Ogle Telephone Company furnished labor and materials to install the signs at no charge. The colors included a cream background, with lettering in red and brown, and a tree splashed in green. The signs are no longer standing, but they are remembered fondly by many who think the message still applies.

These landmark stone gates on East State Street mark the entrance to Sycamore Community Park. Voters approved establishment of a park district in 1923, and the 56 acres of farmland that made up the original park were purchased in 1924. The 4,000 attendees at the park's dedication on July 16, 1925, could participate in baseball, swimming, golf, tennis, horseshoes, and bait casting in what had been pastureland less than a year before.

This rustic cedar log shelter house at Sycamore Community Park was constructed in 1936 as a project of the WPA, the Depression-era federal employment program. The WPA also built two cement tennis courts, planted trees and shrubbery, oiled roads, and landscaped the new swimming pool in the park that year.

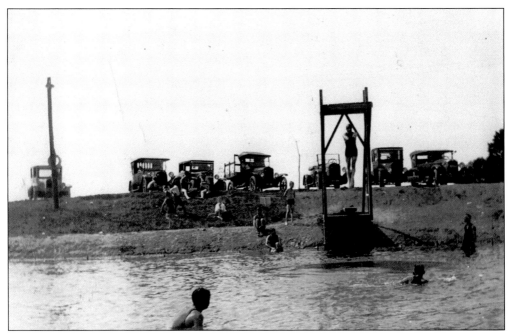

This photograph shows people enjoying the first Sycamore Community Park swimming pool, which was developed from a lagoon soon after the original 56 acres of parkland was purchased in 1924. After it was replaced by the park's cement pool in 1936, the old swimming pool continued in use as an ice skating rink. In the late 1950s, the lagoon was filled in.

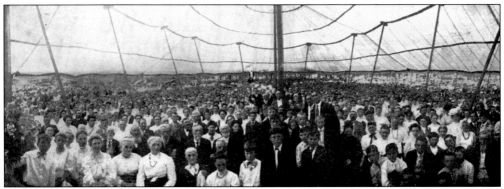

This crowd gathered under the huge Chautauqua tent at Marsh's Park to hear evangelist Billy Sunday on August 25, 1907. Chautauqua was an adult education movement inspired by the Sunday School Institute at Chautauqua, New York. Traveling Chautauquas set up their tents in small towns across America during the summer, offering musical and theatrical programs as well as lectures for a modest fee. Clarence Darrow, Billy Sunday, and William Jennings Bryan were among the celebrities featured locally. Chautauquas, generally lasting for 10 days in late August, were held in Sycamore from 1903 until 1925.

The Mighty Maroons boys' baseball team had this formal portrait taken at the local M. F. Carlson studio around 1900. Mascot Raymond Branen is front and center. Team members, from left to right, are (second row) Will Sell and Rex Shield; (third row) Doug Langhorn, George Murray, captain Charles B. Townsend, Earl Branen, and George St. Dennis; (fourth row) Harry Cornwell, Jim Branen, and Walter Wallmark.

The Christmas murals with religious themes that decorated the courthouse from about 1937 to 1956 are fondly remembered by many. The murals were installed above the front door at the second floor balcony level. They were sponsored by the chamber of commerce and designed by commercial graphic artist Arlie Pearce and high school art teacher Cora Miner. High school students from manual arts and art classes helped with construction and painting.

The inscription on the back of this photograph identifies it as "Hospital Staff, 1923." It was taken outside the old Sycamore Municipal Hospital at 225 Edward Street. At that time, the hospital had a capacity of 30 patients in a converted home given to the city by the heirs of Eleanor Townsend and a wing constructed in 1913 with funds donated by Mary E. Stevens. Standing, from left to right, are Mae Briggs, Peter Husberg, Anna Swedberg, and Hilda Nelson.

This 1897 meeting notice for the IOOF includes the organization's three-link symbol, which stands for Friendship, Love, and Truth. Sycamore Lodge, No. 105, was first chartered in 1852. Prominent early members included Charles O. Boynton, James S. and John C. Waterman, Dr. Orlando M. Bryan, Carlos Lattin, and Joseph Sixbury. The lodge became inactive in mid-1860 but had its charter restored in 1872. When the Alida Young Temple's IOOF cornerstone was laid in 1889, the *True Republican* newspaper noted of the lodge's benevolent work: "It has expended large sums of money in annually caring for the sick, burying the dead, and assisting the widows and orphans of its deceased members." The affiliated Ellwood Encampment No. 173, IOOF, chartered in 1876, was named in honor of Alonzo Ellwood.

The Sycamore Driving Park Association was organized in 1874. The association had capital stock of $10,000 in 100 shares. In September of its first year, the park had 147 entries for trotting and pacing, with purses totaling $4,700. The oval racetrack was located south of town just inside Cortland Township, as shown on the 1892 plat map. In 1878, the group reorganized under the name Mambrino Driving Park Association. Mambrino was a legendary 18th-century trotting coach racehorse in England. Many of Sycamore's most prominent citizens, including Frederick B. Townsend, George W. Nesbitt, O. S. Holcomb, James Branen, and F. E. Claycomb were leading the enterprise in the 1890s.

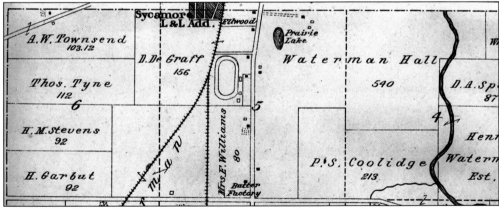

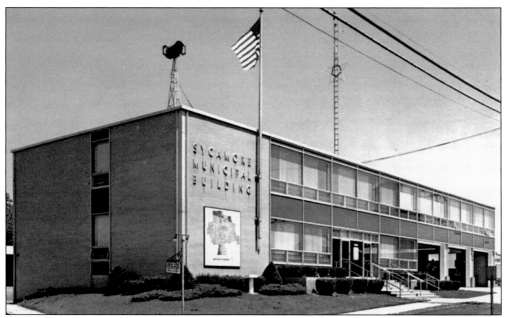

When the Sycamore Municipal Building was dedicated on May 10, 1958, there was a gala celebration with a luncheon, parade, and speeches. City offices and the police, fire, water, and street departments were now housed in a single modern facility. In 1956, voters approved a bond issue for the building after higher property insurance rates were threatened due to the inadequate old fire station on South Maple Street.

This is a photograph of Tom Weeden (left) and Brian Bend with their prizewinning sheep at the Sycamore Farmers' Club Junior Fair in 1970. This fair was held for many years in conjunction with the DeKalb County 4-H show at the Sandwich Fair Grounds. In 1909, a group of farmers and other area leaders, mainly from Sycamore, petitioned the secretary of state to incorporate the DeKalb County Farmers' Club. Frederick B. Townsend, Elmer Boynton, and Henry H. Parke were among the men whose objective was "to promote more profitable and more permanent methods of agriculture in DeKalb County." In 1911, the name was changed to Sycamore Farmers' Club. (Courtesy of the DeKalb County Farm Bureau.)

In an effort to end double-parking and raise revenue, the City of Sycamore installed 275 parking meters in the business district in May 1947. Very detailed instructions about how to use this newfangled equipment were printed in the newspaper. The two-slot meters provided 12 minutes of parking for a penny and one hour for a nickel. Amazingly the rates are the same 60 years later. In 1947, violations cost $1 and required a traffic court appearance. Today the bargain 25¢ parking fines, which can be deposited on the spot, are one of the charms of downtown Sycamore.

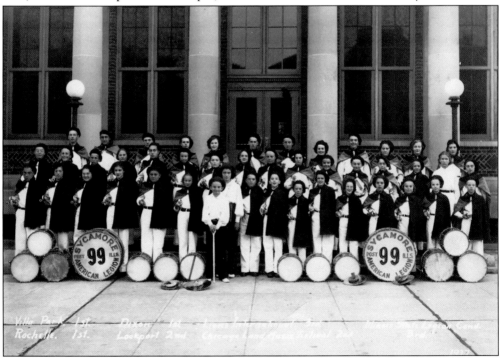

This 1937 photograph of the Sycamore American Legion Post 99, Junior Drum and Bugle Corps was taken in front of the post office. The first appearance of this group was in a parade on Memorial Day in 1935.

The striking entrance gates of Elmwood Cemetery were listed on the National Register of Historic Places in 1978. The cemetery's 1865 incorporation date is on top of the archway. The cast iron pillars and arch, with wrought iron gates and fence, date from 1897. The Elmwood Cemetery Company organized, sold stock, and purchased 18 acres of land from the Henry L. Boies farm in 1865. Those who had loved ones in the two existing cemeteries on the south and east sides of the village were informed that they were expected to buy lots for reburial in the new cemetery. If lots, which sold for $15 to $50, were not purchased, remains would be transferred to unmarked common graves in the new cemetery's potter's field section. In an era when removing entire cemeteries was not unusual, the old burying grounds were to become public parks.

The entrance to Mount Carmel Cemetery, owned by the Church of St. Mary, is located on the western edge of Sycamore. The main gate faces Illinois Route 64. An existing cemetery was purchased from Miranda Quinn for $193 and an additional two acres from Jesse Alden for $350. The grounds were improved and the cemetery was consecrated in September 1891. Contributions included 30 elm trees from Charles Lattin, wire for a fence from George Hepton, and sidewalks from John Ryan and Lattin. Additional acreage was purchased over the years. In 1968, Emma and Harry Bollinger contributed funds for the new entrance.

Generations of students have walked past this towering statue of Abraham Lincoln that has presided over the halls of Sycamore schools since the 1930s. No record exists as to who purchased the statue for the Sycamore school district. A photograph of it appeared in the 1930 yearbook when it was in Sycamore High School. It was originally off-white, but has since undergone restoration and presently is a silver-bronze color. The statue is 7 feet 2 inches tall on a 24-inch square base that is 4 inches high. It is made of plaster of paris and the head is a separate piece. The body is modeled after a statue in Chicago's Lincoln Park commonly known as the Standing Lincoln. The head is believed to have been modeled after busts of Lincoln by Max Bachman. Such statues were offered in a catalog from P. P. Caproni and Brother of Boston. They could be ordered with a choice of heads and with or without a beard. The statue is now located in the Sycamore Middle School.

This 9-foot-tall mouse sits north of the intersection of North Avenue and Maple Street. Its origin was explained by Bishop Joseph Thomas of the Israel of God Church in a 1987 newspaper article. Thomas said the Katz family had used the mouse on floats promoting their business. The mouse was later donated for placement at the entrance to the summer camp that the church hosted on its nearby wooded property. There it was much enjoyed by the children.

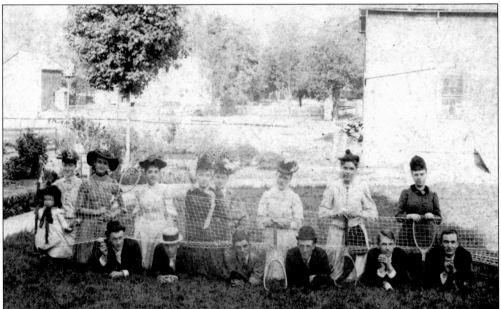

These local guys and gals got together for tennis on Decoration Day, May 30, 1890, before casual attire was acceptable. Pictured, from left to right, are (first row) ? McDonald, H. M. Whittemore, George Nesbitt, Will Dutton, Ned Burst, and Will Ward; (second row) unidentified, Jane Faisler, Dora Connart, Gertie C. Whittemore, Bird Hills, Abby R. Goddard, Ethel Shattuck, Emily Waterman, and Mazie W. Morris.

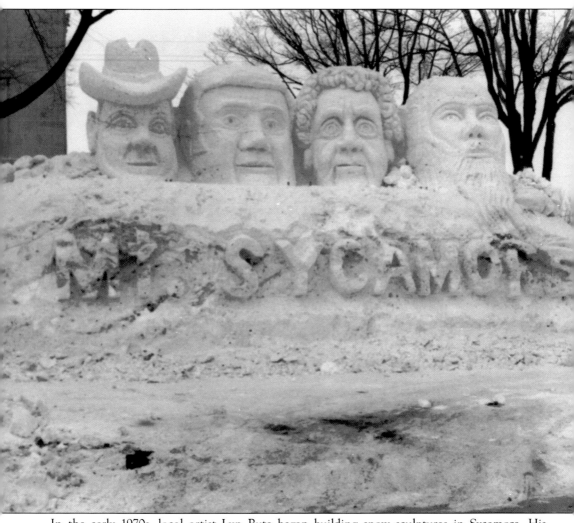

In the early 1970s, local artist Lyn Bute began building snow sculptures in Sycamore. His sculptures of Santa Claus and Mickey Mouse brought him local fame. In 1976, his bicentennial snow sculpture of the Statue of Liberty brought national attention. In February 1979, Bute and fellow artists Doug Aken and David Stott completed their 72-ton Mount Sycamore on the east side of the courthouse. Copying clay models, the trio used chisels, draw blades, adzes, and shovels, to come up with these four well-known faces who greeted travelers on State and Main Streets. Pictured, from left to right, are Mayor Harold "Red" Johnson, former police chief Joseph Salemi, retired Sycamore art teacher Cora Miner, and the artist himself, Lyn Bute.

DIXIE INN	—Home of the 25 Cent Meals—
	Sundays and Holidays 40 Cents
	E. S. SIMS, Proprietor
Phone 563	512 California Street

This is a 1930 advertisement for the Dixie Inn restaurant on North California Street. The business, located near the Anaconda plant, was opened by Eugene Spencer "Dixie" Sims about 1915. Sims left his native Tennessee at age 17 to find work in Chicago, which led him to Sycamore in 1899. As a young man, he was a boxer. In 1909, he had a match with the renowned Dixie Kid (Aaron Lister Brown) in Memphis. Sims's son Allen and daughter-in-law Fannie began operating the Dixie Inn in the 1940s. A former school teacher and principal, Allen was the first male African American to graduate from Sycamore High School. After the deaths of her husband and father-in-law, Fannie Sims continued operating the business as Fannie's Dixie Inn. Many area residents fondly remember eating barbecued ribs and chicken there. The restaurant was destroyed by a fire in 1972.

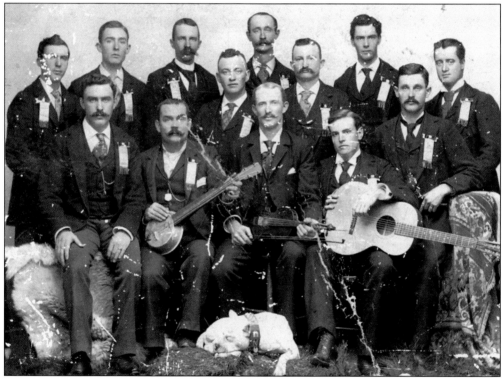

This photograph of members of the Stranglers Club includes, in unknown order, Jack Betty, Will Kelly, Charles Brown, Mert Singer, George Maxfield, Lou Myers, Will Ballard, Robert Hill, Eddie Boyle, Johnie Tucker, George Sell, Wirt Anderson, and Dan Cliffe. In 1898, the Stranglers opened a gymnasium on the second floor of the Wilkins Block, the frame structure that preceded the Pierce Building at the southwest corner of Somonauk and State Streets. Equipment in the gym included rings, bars, a trapeze, a punching bag, a rowing machine, and an 18-foot boxing ring. All of this was available for a $5 annual membership fee. A young "Cyclone Johnny" Thompson practiced boxing in the club's ring before becoming a well-known professional boxer. After a time, the Stranglers rented space at Ward's Opera House.

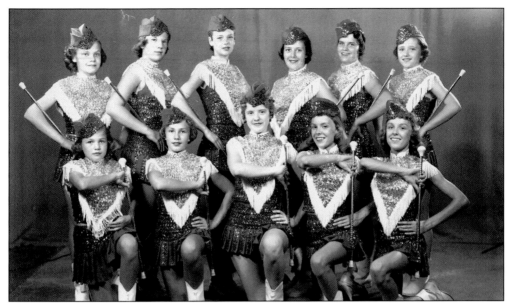

Marlyn Lenschow Burkart began teaching baton twirling while still in high school. In 1956, she assembled her first competitive team, the Marlyn Majorettes, a twirling corps of 12 girls. Members included, from left to right, (first row) Marilyn Seitzinger, Marcia Storey, Marlene Nichols, Sarah McCormick, and Mary McCormick; (second row) Mary Jane Hintzche, Donna Miller, Tammy Griswold, Ruth McQueen, Marilynn Russell, and Maxine Maness. The 12th majorette, Sandra Gittleson, was not present. (Courtesy of Marlyn Lenschow Burkart.)

In this photograph, Burkart leads her majorettes in a Rockford parade. The Marlyn Majorettes and Majors Drum Corps now includes a color guard. This musical youth group has marched in parades and competitions throughout the United States and Canada. Dressed in sparkling fuchsia, silver, black, and white uniforms, they are a popular feature of the annual Sycamore Pumpkin Festival parade. Over 1,000 trophies and many championship titles have been awarded to Burkart and her colorful corps from Sycamore. (Courtesy of Marlyn Lenschow Burkart.)

The idea for the Sycamore Pumpkin Festival began with Halloween enthusiast Wally Thurow filling his own front yard with decorated pumpkins. When Thurow and the Sycamore Lions Club organized the city's first pumpkin festival in 1962, an annual tradition was born. Over 200 pumpkins decorated by school children were displayed on the courthouse lawn that year. A Cinderella princess was elected, and youngsters portraying storybook characters, spooks, and goblins marched in a parade behind the Marlyn Majorettes. Thurow and his famous bicycle became a favorite part of festival. The smiling man with the signature top hat and orange vest was soon known to all as "Mr. Pumpkin."

The kickoff of the annual Sycamore Pumpkin Festival comes when kids of all ages turn the courthouse lawn (below) into a giant pumpkin patch of clever creations. Sponsored by the Sycamore Lions Club since 1962, the pumpkin festival attracts thousands. It has grown to include arts and crafts shows, a house walk, a pie-eating contest, a carnival, and a fun fair. The celebration concludes with a huge parade on the last Sunday in October. The float shown in the photograph above was in the 2000 pumpkin parade.

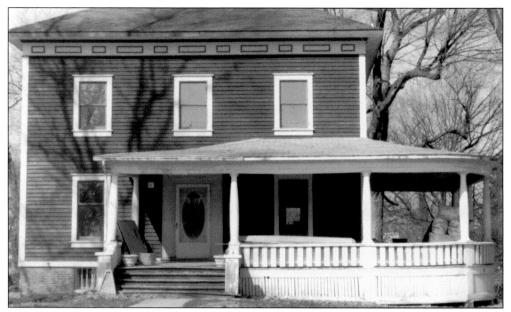

This house at 827 Somonauk Street was built in 1859 by Chauncey Ellwood. In 1902, second owner Frank C. Patten created a place for young people to swim when he deepened the property's pond to eight feet, graveled it, and installed a pump system to keep the water fresh. Dr. John Nesbitt, the third owner of the property, added a crushed stone shore and a pleasure boat in 1914.

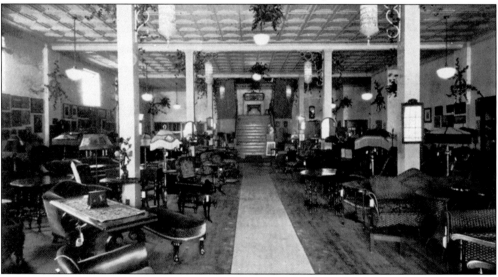

This is the main showroom of the Emil E. Johnson Furniture Mart on Somonauk Street as it looked in 1925. According to a 1929 newspaper article, Johnson had "the largest store building in the county occupied by one concern." He also advertised the largest selection of modern furniture in northern Illinois. In addition, Johnson sold coffins, and as an undertaker, he conducted many funerals in the small chapel in the rear of the building. In later years, Johnson left the furniture business and became a partner with J. H. Van Natta in the mortuary business. Stanley Gullberg and Glen Haines became owners the furniture business. Mayor Harold "Red" Johnson, a longtime employee at the store, became a partner of Gullberg's son, Chuck, and the business was renamed Gullberg and Johnson.

Saved from the wrecking ball, this "painted lady," now at 708 Somonauk Street, was originally the home of James E. Ellwood, a Sycamore merchant. It was built in 1859 on the west side of Somonauk Street. At one time, it served as a convent for St. Mary's Catholic sisters and later as offices for Sycamore Municipal Hospital. Slated to be torn down in 1989 to make room for hospital parking, the house was purchased by Margaret Baack, moved across the street, and restored to its former beauty. The photograph shows the moving of the house in 1989.

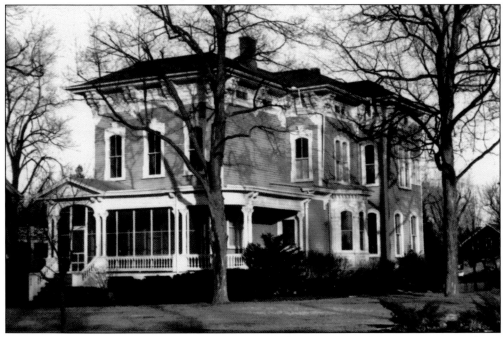

This house at 450 Somonauk Street was built in 1869 for George P. Wild, a Sycamore merchant. Before his 1906 death, Wild was an officer of the Pierce Bank for about 15 years.

The Lustron-built home at 942 DeKalb Avenue was constructed of steel from the foundation to the roof, with built-in steel cabinetry throughout. The two-bedroom home was built in one month for Earl and Kathryn Wilson in 1949 at a cost of $9,500. The Lustron Corporation declared bankruptcy in 1950, ending its brief production of steel prefabricated homes.

This home, which was built in 1870 when Somonauk Street was dubbed "swell head row," is now known as the Pay-It-Forward House. It provides overnight accommodations to people related to patients receiving treatment at Kindred Hospital (formerly Sycamore Municipal Hospital) next door. The house, which is located at 719 Somonauk Street, was built by William A. Morgan and owned by many others over the years. Pay-It-Forward House opened in March 2005.

INDEX

Adee, Charles, 53
Alida Young Temple, 25
American Legion, 114
Anaconda Wire and Cable Company, 2, 53, 54, 78
Barker and Sullivan drug store, 20
Barnes, Eli, 7, 10, 13, 102
Beard family, 37, 91
Bethel Assembly of God, 62
Blumen Gardens, 80
Boies, Henry L., 2, 101, 115
Borden Milk Plant, 76
Boynton family, 13, 30, 31, 32, 97, 111, 113
Bryan, Dr. Orlando M., 98, 111
Burkart, Marlyn Lenschow, 120
Bute, Lyn, 7, 118
Butzow, Charles "Chick," 55, 56
Central School, 69, 71
Chandler, Eugene C., 76
Charlie Laing Memorial Park, 66
Chautauqua, 14, 32, 109
Chicago and North Western Railway, 7, 48, 49, 54, 76
Chicago Great Western Railway, 50, 51, 52
City Hotel, 10
Columbian Literary Club, 93
community center, 7, 58, 59
Congregational church, 41, 58, 61, 66, 99
Church of St. Mary, 64, 115
Danielson, Clifford, 105
Davis sisters (Edna, Ella), 89
DeKalb County Courthouse, 33, 34, 35, 37, 38, 39, 40, 41, 44, 66
DeKalb County Jail, 42, 43, 92
DeKalb County seat referendum, 98
DeKalb County Sheriff's Department, 44
DeKalb-Sycamore Interurban Traction Company, 45
Dixie Inn, 119
Dolder, sheriff Helena, 92
Downtown Shoes, 9
Dow's Academy, 68

Dustin, Gen. Daniel, 35, 95, 100
Dutton family, 67, 93, 95, 100, 117
Dutton, Gen. Everell F., 67, 95, 100
Dutton, George E. Sr. family, 67
East School, 70
Electric Park, 45
Ellwood, Alonzo, 97, 111
Ellwood, Col. Isaac L., 30, 35
Ellwood, James E., 100, 124
Ellwood, Reuben, 18, 97
Elmwood Cemetery, 97, 100, 102, 115
Emil E. Johnson Furniture Mart, 123
Evangelical Lutheran Church of St. John, 66
Fargo garage, hotel, and theater, 17, 18
Federated Church, 58, 61, 67
Ferguson's drug store, 21
First Baptist Church, 62
First National Bank, 22
Galena and Chicago Union Railroad, 7, 48
Garnsey, George, 27, 30, 60
George's Block, 22, 24
Grand Army of the Republic (GAR), 35, 37, 85, 95
Gullberg and Haines, 105, 123
Hamsmith, Mary, 90
Henderson's Department Store, 21
Hillquist family, 17
Holcomb family, 93, 103, 112
Hole in the Wall, 10
Hopkins, Rufus, 103
Ideal Industries, 7, 75
Illinois National Guard armory, 15, 16
Illinois Thresher Company, 78
Israel of God Church, 63, 117
James' Block, 22, 24
Johnsen House, 19
Johnson Reclining Rocker, 77
Johnson, Mayor Harold "Red," 7, 105, 118, 123
Joiner, Earle W., 6, 40
Joiner, Ralph and Bertha, 4, 6
Kellogg, Jesse C., 7, 14, 99
Kinsloe, Albert S., 38, 98

Knights Templar, 41
Lahti, Richard (Ric), 26
Lattin, Carlos, 7, 9, 47, 65, 69, 102, 111
Lincoln, Abraham, statue, 116
Loptein, Claus, 11
Lovell, L. C., 10, 12, 22
Lustron home, 125
Mambrino Driving Park, 112
Mansion House, 10, 13
Marlyn Majorettes, 7, 120, 121
Marsh Harvester, 14, 54, 79, 96
Marsh, Charles W., 14, 79, 96
Marsh, William W., 14, 79, 96
Masons, 25, 41
Methodist Episcopal church, 65
Midwest Museum of Natural History, 7, 59
Mighty Maroons, 110
Miner, Cora, 110, 118
Modern Woodmen of America, 28, 29
mouse, 117
Mount Carmel Cemetery, 115
National Bank and Trust Company, 21, 22, 26, 105
Nesbitt, Dr. John, 123
Nesbitt, Esther Mae, 91
19th Amendment (Suffrage), 93
North Avenue Baptist Church, 63
Independent Order of Odd Fellows, 25, 111
Ohlmacher, Christian J., 54
Opportunity House, 70
Paper Doll House, 32
parking meters, 114
Patten, Frank C., 78, 80, 123
Paulsen Appliance and Electronics, 20
Pay-It-Forward House, 7, 125
Pierce Building, 7, 21, 119
Pierce, Daniel, 21, 22, 46
popcorn stand, 15
post office, 24, 25
Potter, Horace, 95
R. Ellwood Manufacturing Company, 78, 80, 102
Salem Lutheran Church, 68
Seymour of Sycamore, 81
Sims family, 119
soldiers monument, 35–37
South School, 70
St. Alban's School for Boys, 74
St. Mary's Catholic School, 64
St. Peter's Episcopal Church, 60, 102
standpipe, 12, 13
Stevens, Mary E., 59, 111
Stiles Waxt Thread, 81
Stranglers Club, 104, 119
Stratford Inn, 18
Swanson Brothers, 19
Swedish Evangelical Lutheran church, 68
Sycamore Feed Sheds, 28
Sycamore Hospital, 86, 88
Sycamore Airport, 52
Sycamore Baptist Church, 61
Sycamore Chamber of Commerce, 86, 105, 107, 110
Sycamore Community Park, 7, 52, 108, 109
Sycamore Driving Park Association, 112
Sycamore Farmers' Club, 113
Sycamore Fire Department, 55, 56
Sycamore Foundry Company, 78, 80
Sycamore High School, 19, 71, 72, 116, 119
Sycamore Municipal Building, 113
Sycamore Municipal Hospital, 97, 111, 124, 125
Sycamore National Bank, 100, 102
Sycamore Preserve Works, 77
Sycamore Public Library, 13, 15, 97, 106
Sycamore Pumpkin Festival, 120, 121, 122
Sycamore Wagon Works, 84
Sycamore, Cortland, and Chicago Railroad, 7, 48, 49, 102
Thompson, "Cyclone Johnny," 104, 119
Thurow, Wally "Mr. Pumpkin," 7, 121
Townsend, Charles B., 32, 97, 110
Townsend, Eleanor, 32, 97, 111
Townsend, Frederick B., 13, 15, 24, 30, 32, 97, 112, 113
Townsend, Mary Boynton, 32, 93, 97
Turner Brass, 7, 82, 83
Underground Railroad, 14, 61, 99
Universalist church, 7, 58, 59, 61, 67
Ward's Opera House, 27, 119
Waterman Hall, 73, 74
Waterman, Abbie, 60, 73
Waterman, James S., 7, 60, 102, 111
Waterman, John C., 7, 111
Wesleyan Methodist Church, 57
West School, 69
West, Deacon David, 99
Westgate, Dr. Letitia, 7, 28, 86–88
Wetzel Brothers, 20
Whittemore, Mary, 18
Wild family, 46, 124
Wilkins Block, 119
Winn's Hotel, 27
Woman's Relief Corps, 85
Young, Tony, 83

Discover Thousands of Local History Books
Featuring Millions of Vintage Images

Arcadia Publishing, the leading local history publisher in the United States, is committed to making history accessible and meaningful through publishing books that celebrate and preserve the heritage of America's people and places.

Find more books like this at
www.arcadiapublishing.com

Search for your hometown history, your old stomping grounds, and even your favorite sports team.

Consistent with our mission to preserve history on a local level, this book was printed in South Carolina on American-made paper and manufactured entirely in the United States. Products carrying the accredited Forest Stewardship Council (FSC) label are printed on 100 percent FSC-certified paper.